This book is dedicated to the memory of my
dear father Jack Collins.

RADIOS
THE·GOLDEN·AGE

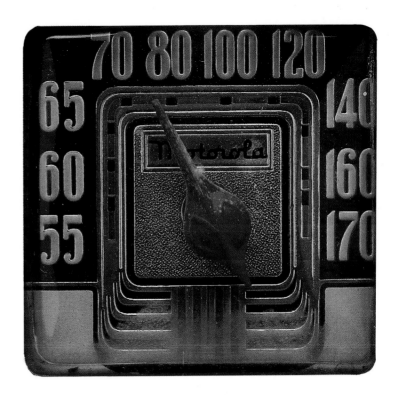

PHILIP COLLINS

RADIOS
THE·GOLDEN·AGE

PHILIP COLLINS

PHOTOGRAPHY BY ROBERT PATTERSON

CHRONICLE BOOKS·SAN FRANCISCO

Copyright ©1987 Fillip Films Inc. Text by Philip Collins.

Printed by Dai Nippon Printing Co., Hong Kong.

Library of Congress Cataloging in Publication Data
available.

Editing: Charles Robbins
Book and cover design: Arnold Schwartzman
Photographs: Copyright ©1987 Robert Patterson

Distributed in Canada by
Raincoast Books
112 East 3rd Avenue
Vancouver, B.C.
V5T 1C8

10 9 8 7 6 5 4 3 2 1

Chronicle Books
San Francisco, CA

CONTENTS:

"I belong to the radio of the month club."

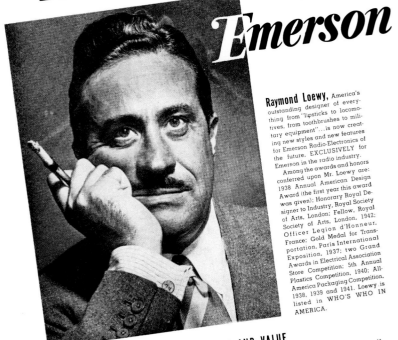

INTRODUCTION:

Over the last twenty years, we have succumbed to the disposable. Throwaway pens, lighters, razors, and polystyrene cups are all part of life in the fast lane. Cheap synthetic compounds have made disposables possible, and we have embraced them utterly.

Today's lifestyles are directed to the easy way, and plastic is valued by consumers for its expedience. Of course, there was a time when plastic created a tremendous revolution in both design and mass production. And now we are oddly nostalgic for those earlier years and the wonderful products they brought us.

Table radios were among the first goods to be made of plastic. Chicago Molded Products built the first plastic cabinet in 1931 for Kadette. Phenolic, Urea, Casein, and other plastic compounds accounted for 95 percent of table models by 1950, and wood had become the staple of TV sets and console radios, although early televisions had occasionally been housed in plastic. Metal and mirrored radio cabinets were made in very limited numbers.

Many of the six hundred manufacturers flourishing in the United States between the late twenties and early forties sought to put a "radio in every room." They hired famous industrial designers to contribute to inherent obsolescence by introducing new models every year. Raymond Loewy, Russel Wright, Serge Chermayeff, and Dorwin Teague were all recruited to foster imaginative variations in cabinet style.

Radio programs themselves remained the same, but the staggering variety of designs from those years is evidence of a golden era when creativity, ingenuity, and productivity gave us exciting radio cabinets. In designing them, the artist hoped to reflect the streamlined and moderne concepts, ideas usually associated with automobile radiator grilles, railroad engines, and airplanes.

Today, the miniaturization of parts has eroded our desire for innovative cabinet design. Instead, boxes in brushed aluminum offer blinking lights and touch-sensitive buttons for the stereo enthusiast. Radios can now be a plastic box the size of a cigarette pack or a large "ghetto blaster" trailing a deafened mass of unwilling listeners in its wake.

The old radios photographed here suggest that there was indeed life before Rock and Roll, and it came through four inch speakers. Radio was the most important source of news and entertainment in the first half of this century.

Sadly, most of the receivers that gave us the nightly reports of Hitler's activities in Europe, of the explosive demise of the airship Hindenburg, of Joe Louis' defeat of Max Schmeling, and of Orson Welles' production of "The War of the Worlds," are now resting under layers of dust in attics and cellars. Many have, however, been rescued. The following pages record some memories of an age when the table radio could not only be listened to but also admired.

In an attempt to propagate the idea of a radio for every room, manufacturers keenly pursued the opportunity to produce frivolous designs as merchandising tie-ins with films, sports figures, radio programs, or consumer products.

The famous Charlie McCarthy set features a molded metal effigy of our hero, perched on a ledge in front of the speaker grille and gazing benignly at the listener. Hopalong Cassidy, Snow White, Mickey Mouse, The Lone Ranger (unfortunately without Tonto), and the Dionne Quintuplets all promoted five-tube sets bearing their popular images.

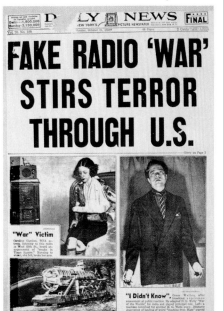

Corporations were keen to get their messages across, not only through their sponsored shows but additionally in visual representation of their product; hence the Coke bottle radio, the Coca-Cola Cooler and Pepsi refrigerator radios, the various beer and champagne bottle radios, the Champion Sparkplug radio, and the radio station radio (in the shape of a large microphone with the appropriate station initials emblazoned above.)

The nicotine fancier was treated to the Smokerette with a provision for four pipes, loose tobacco, cigarettes, and ashtray, all molded into a brown bakelite design which incidentally housed a radio. Baseball fans were not ignored. The "Mickey Mantle" reminded the listener who hit the most homers.

Tipplers had to wait until 1945 before they could enjoy the Porto Baradio, featuring decanters and glasses and recesses for entertaining at cocktail hour. Movie stars and others with money were indulged with expensive mirrored sets that reflected not only the buyers' lovely faces but also the blue and peach interiors of their Hollywood mansions. A "Mother's Day" set was offered at $35 in 1947 for affluent children to express their appreciation of Mom.

Imaginative designers cloaked Amplitude Modulation sound in a variety of disguises — cameras, dice, book cases, clocks, skyscrapers, ships, globes, bottles, pianos, and jewelry cases. Here then, for all those who don't know a megacycle from a ten speed, are those extraordinary radios of yesteryear. The music goes around and around, and it comes out here

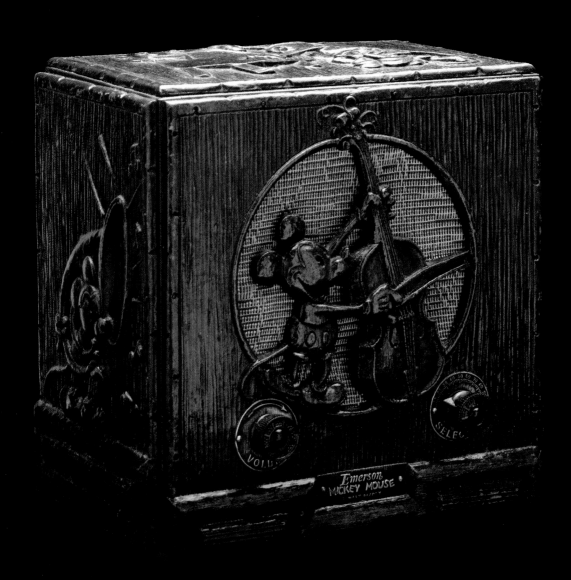

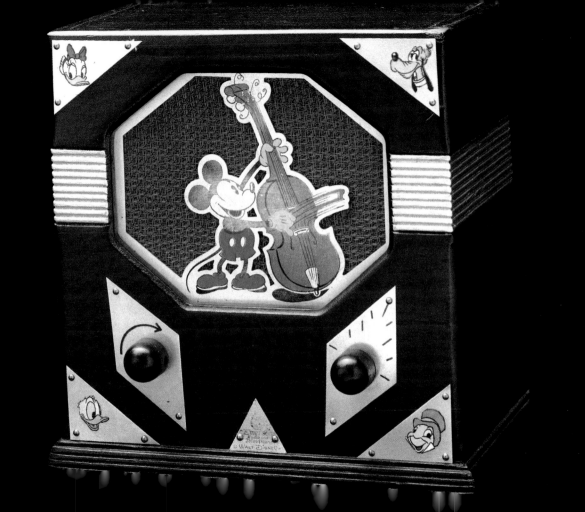

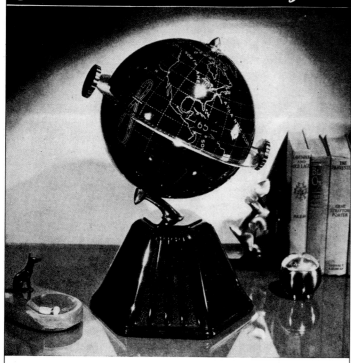

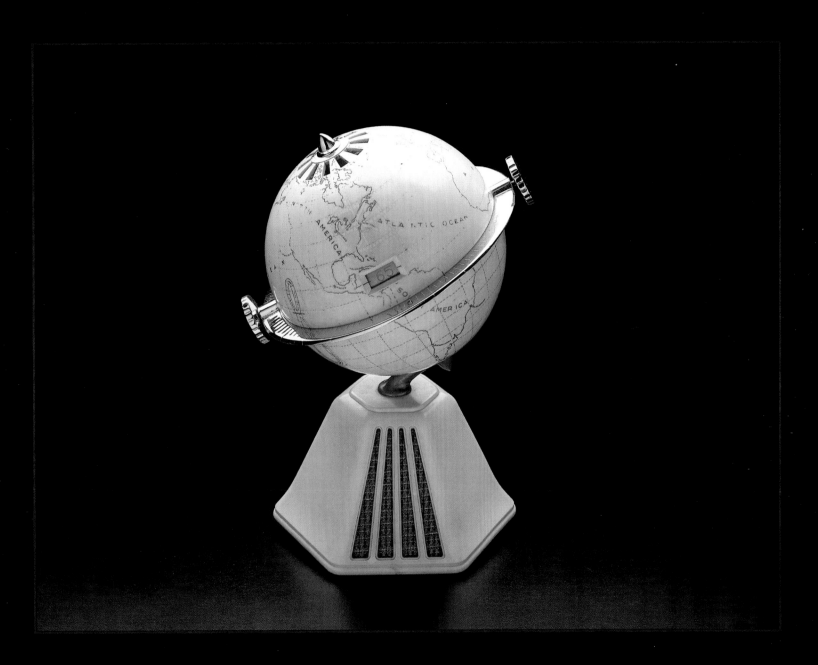

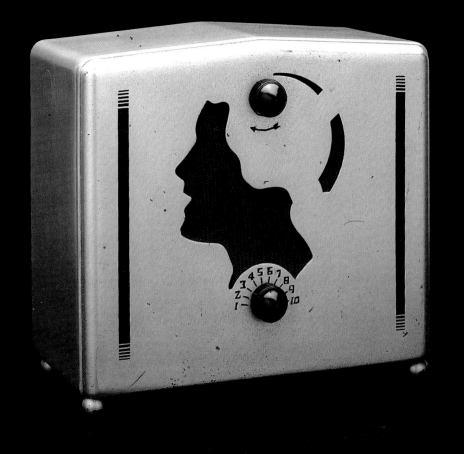

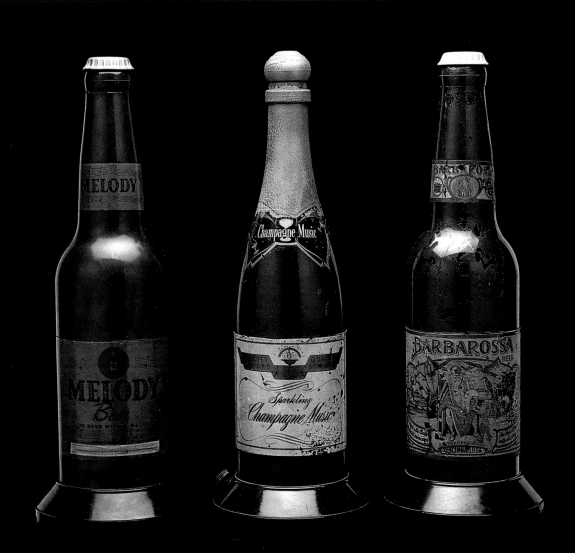

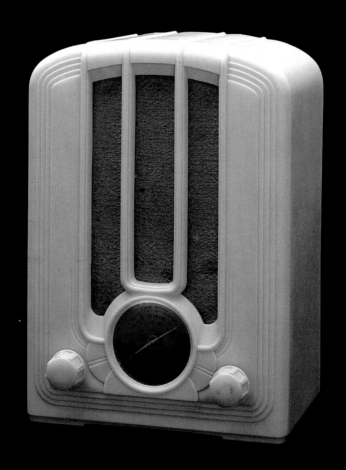

18 Emerson 1935

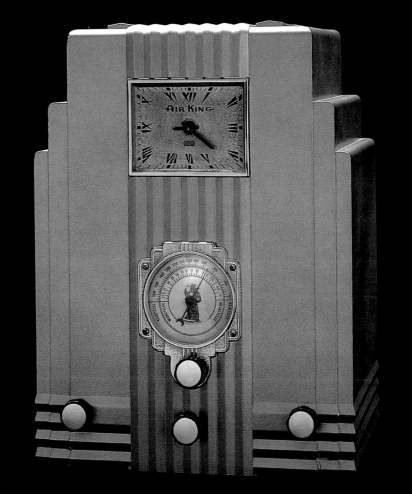

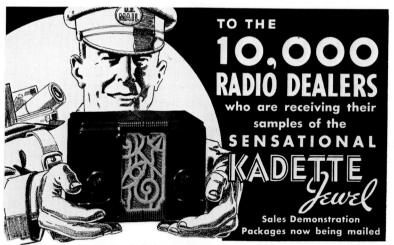

TO THE 10,000 RADIO DEALERS who are receiving their samples of the **SENSATIONAL KADETTE Jewel**

Sales Demonstration Packages now being mailed

A NEW TYPE OF RADIO...
...INTRODUCED IN A NEW WAY

Kadette Distributors Rendering Unique Service to Dealers

Right Now—this month Kadette jobbers are sending to 10,000 dealers samples of the new Kadette Jewel radio. Also an illustrated announcement of the entire International Kadette Line. This is new in radio merchandising. There is no "High Pressure" salesmanship here. You are permitted to look over the 1935 Kadette, taking your own time.

Let Kadette Speak for Itself

When you open your Demonstration Package don't stop at admiring its amazing beauty. Put the Kadette Jewel to every reception test you can think of and you will marvel at its performance. Take it apart and see the simplest, cleanest, most rugged chassis ever designed. You'll then know why Kadette alone can offer their famous "One year-one dollar" service **guarantee.**

Complete Merchandising and Dealer Help Service

Don't fail to study the merchandising plan for retailers. Take advantage of the dealer helps that come with Kadette assortments—window and counter displays, circulars for mail or personal distribution and newspaper ad and mat service. Put into operation the merchandising suggestions evolved by one of radio's outstanding merchandising authorities.

• • •

The Kadette Line is up to the minute—alive. Priced from $13.50 to $34.50 to meet the demand. Don't overlook the many outstanding values in larger models. Note especially the prices of the 1935 Kadette Line. Here is a proposition that is "out of the rut". Get in on a good thing. Order your assortments and start selling NOW.

DEALERS—If you have not received your Kadette Jewel sample or received notice of its shipment, get in touch immediately with your jobber. In territories not now served by Kadette Jobbers, the factory will upon request mail you your demonstration package at full discount, C. O. D., transportation prepaid.

JOBBERS—Over fifty leading jobbers are co-operating in introducing by mail this new exceptional radio. There is still some territory open. If you want a product with a sales plan that will quickly boost your sales at a lower sales cost—Wire today.

KADETTE Jewel
International Radio Corp. Ann Arbor, Mich.

LIST PRICE $13.50

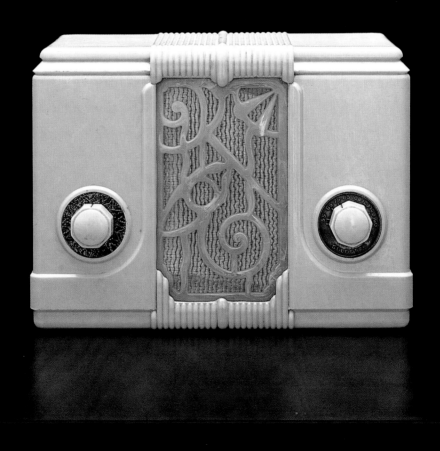

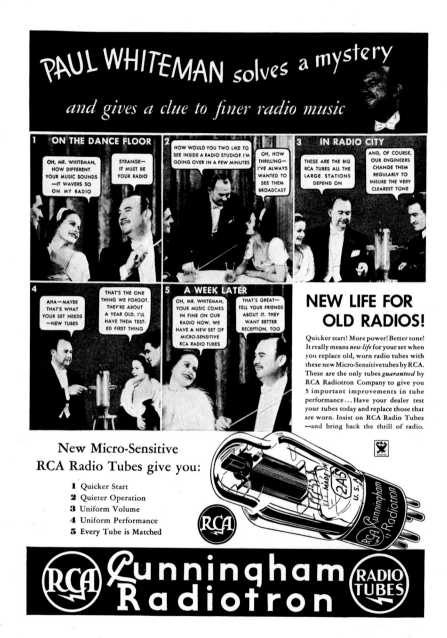

22

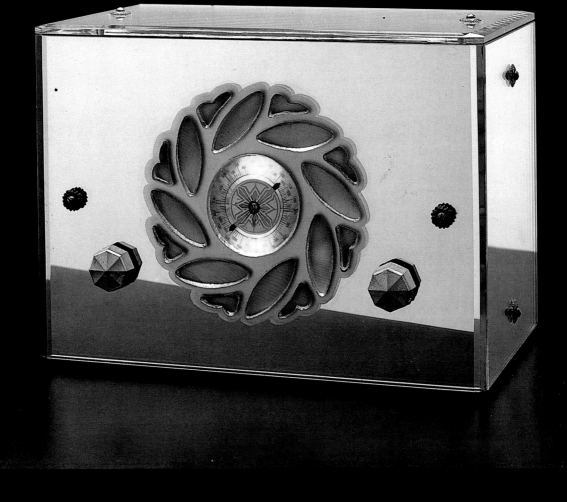

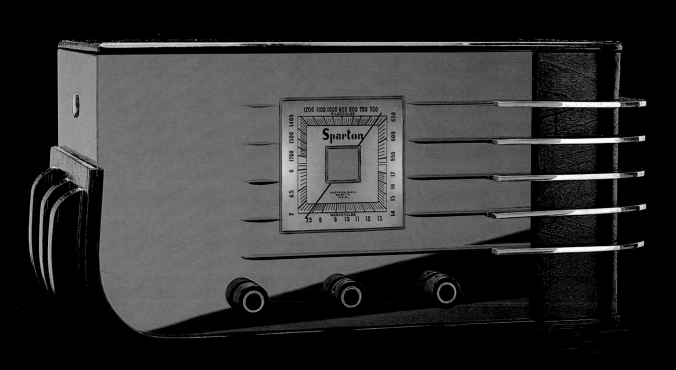

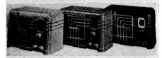

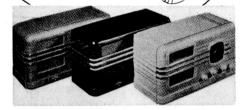

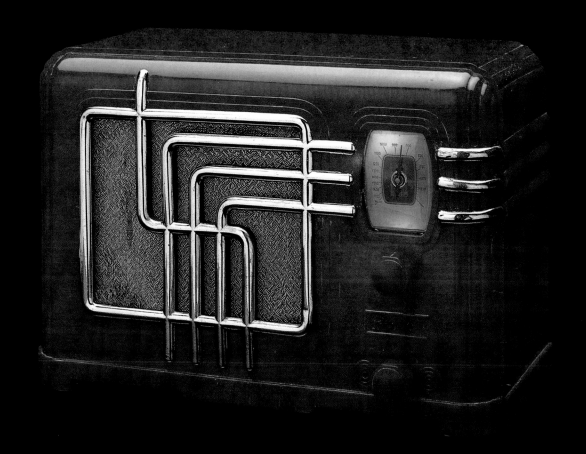

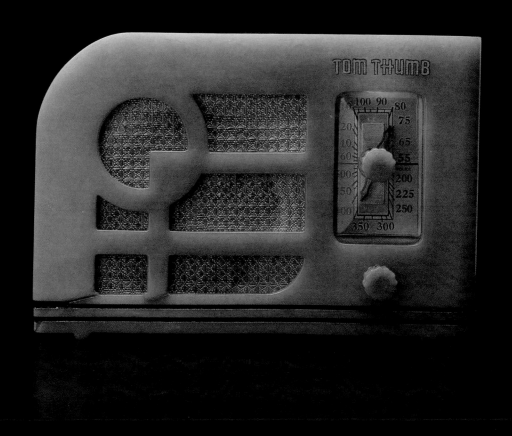

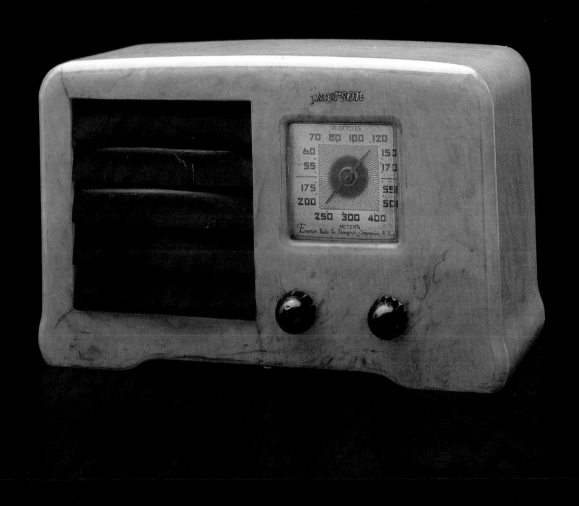

The radio dial shows various markings.

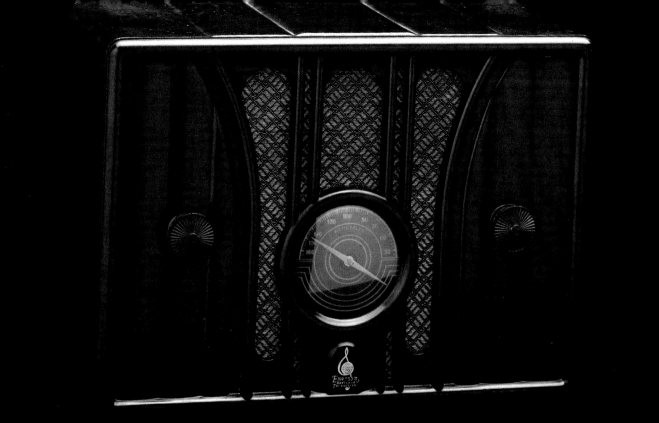

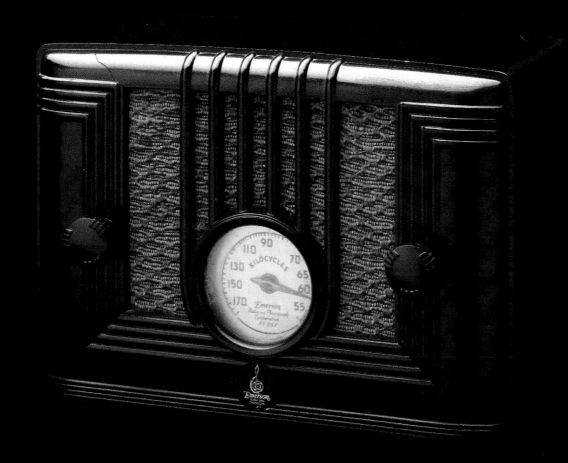

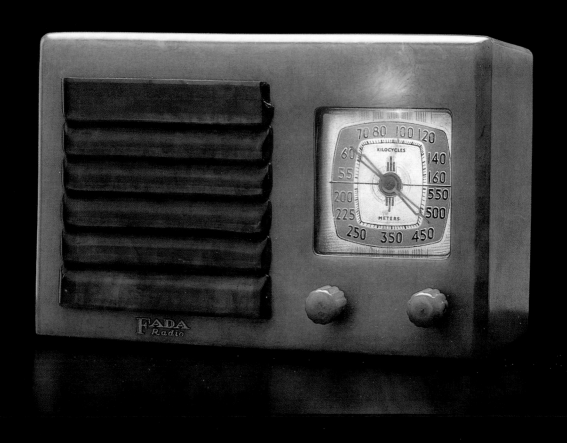

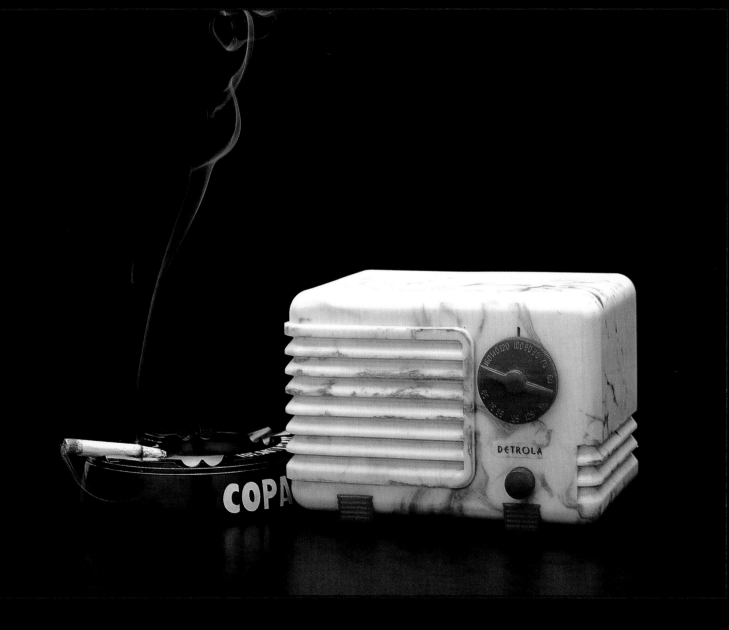

Detrola "Peewee" 1938 **33**

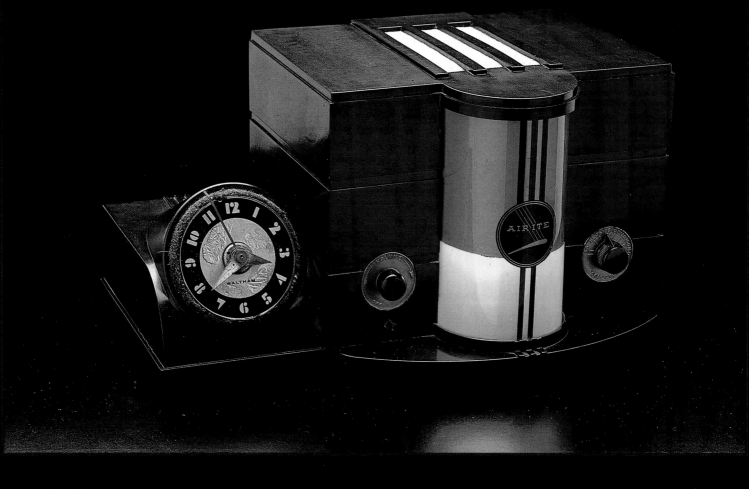

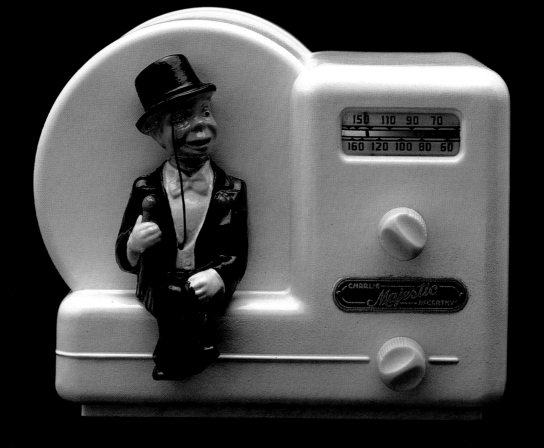

Majestic "Charlie McCarthy" 1938 **35**

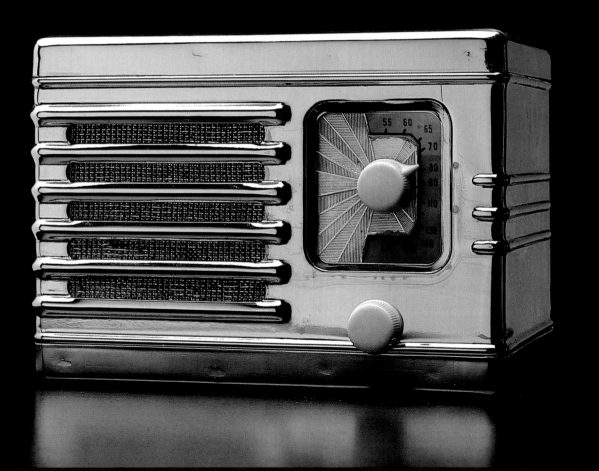

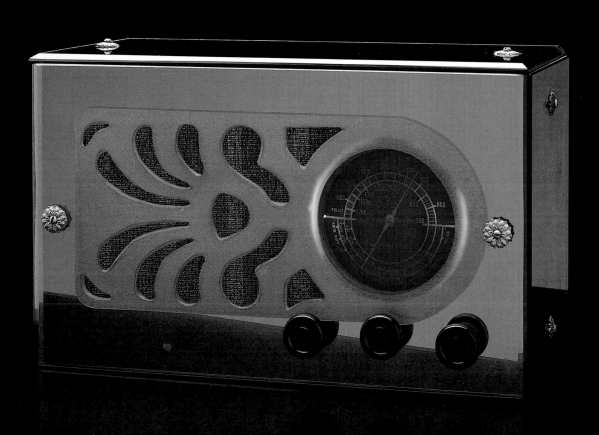

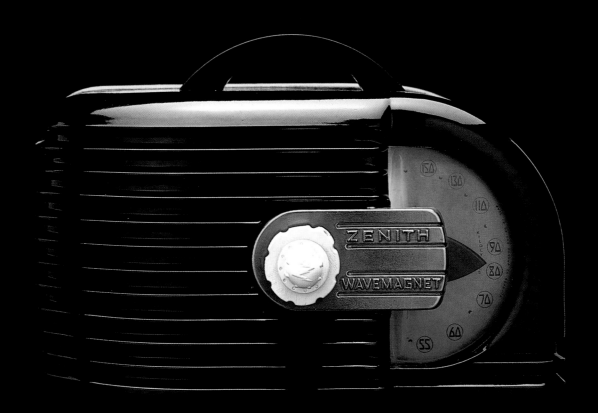

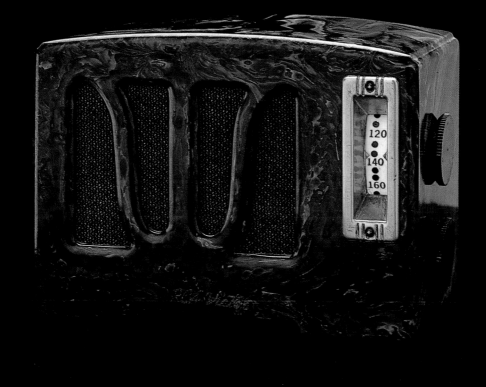

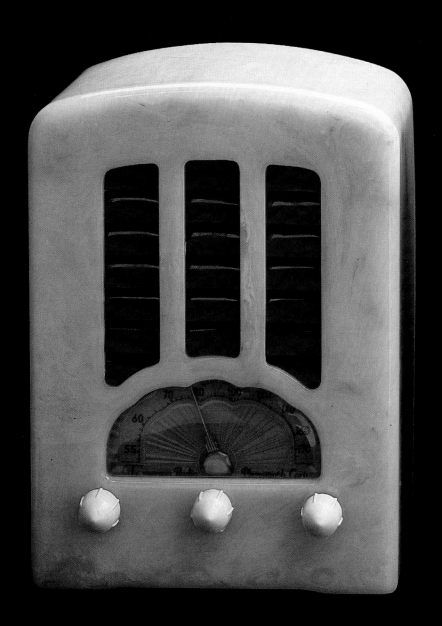
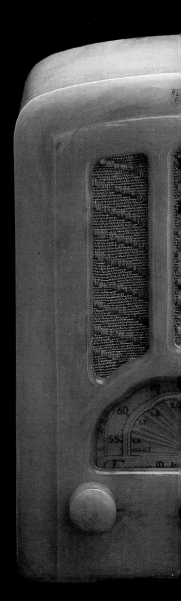

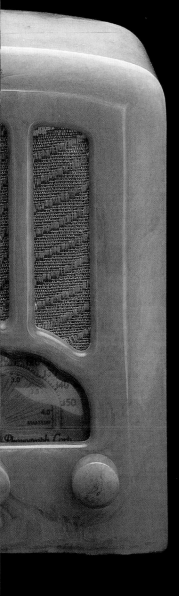
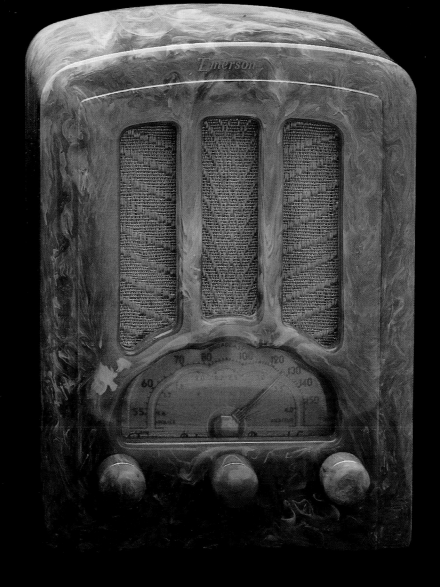

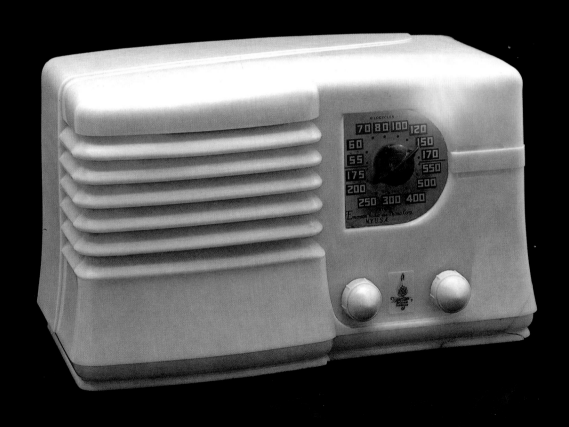

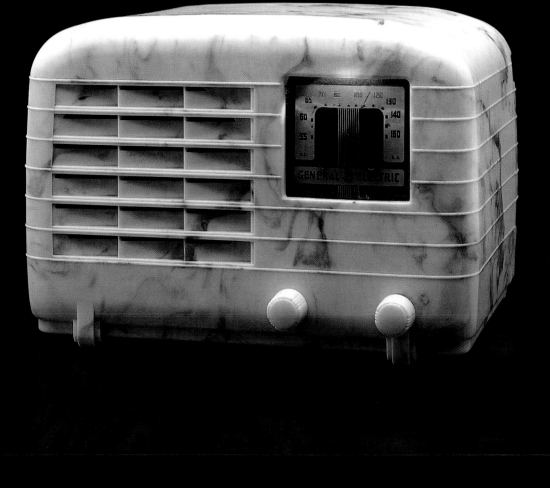

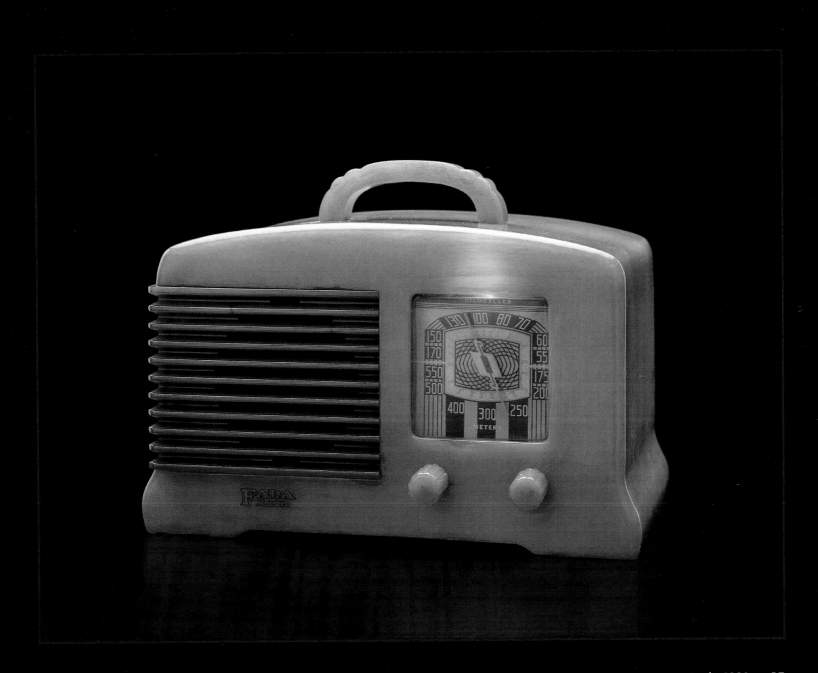

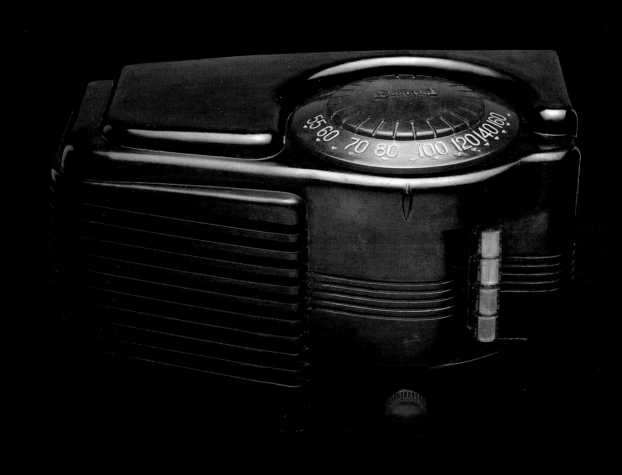

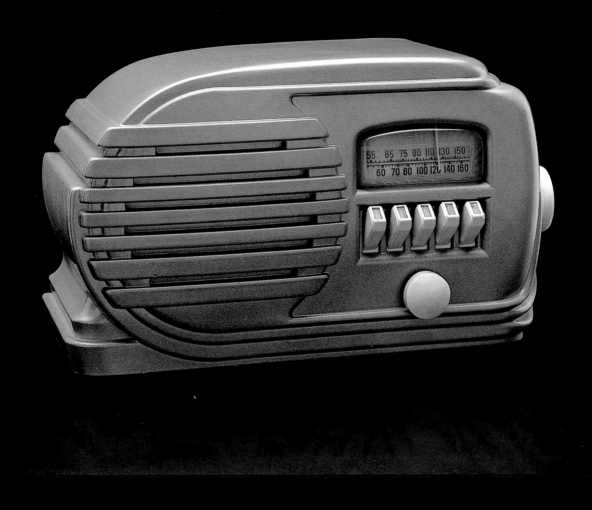

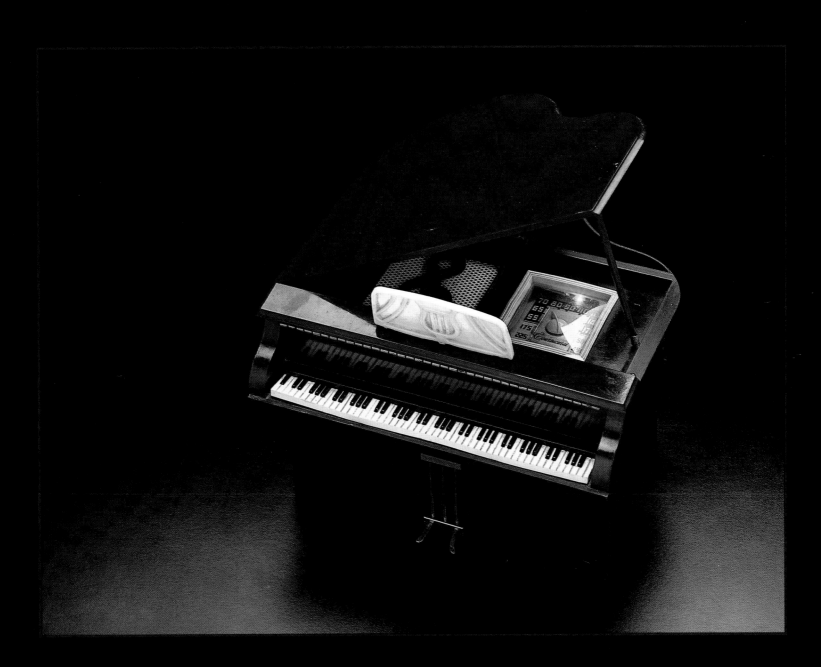

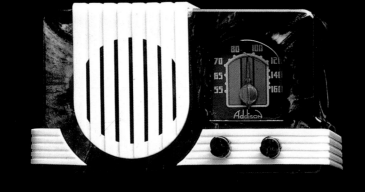
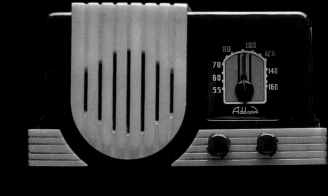
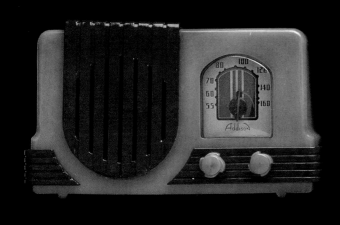
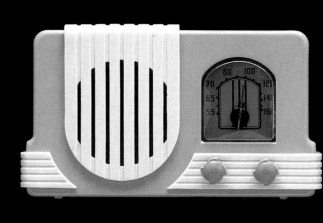
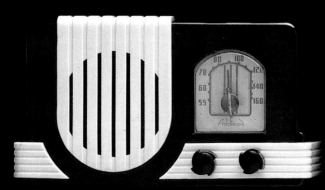
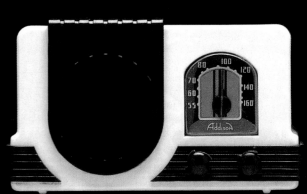

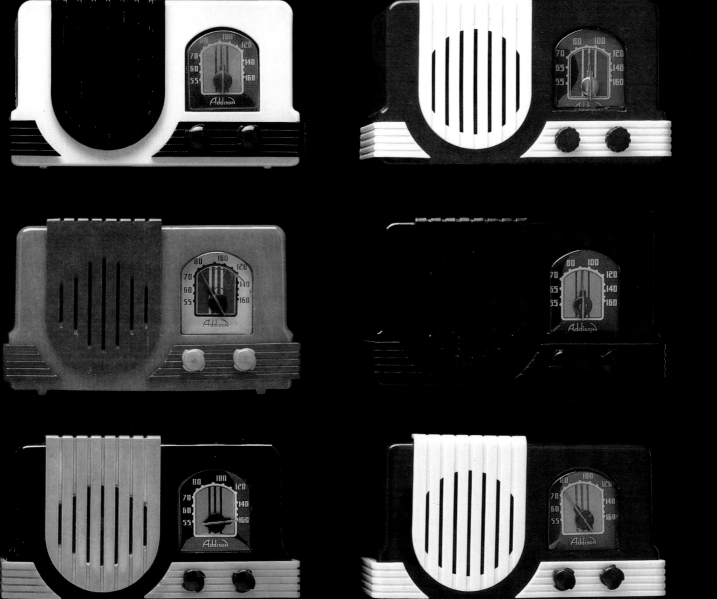

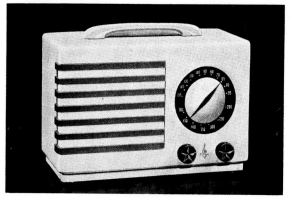
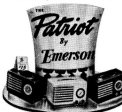

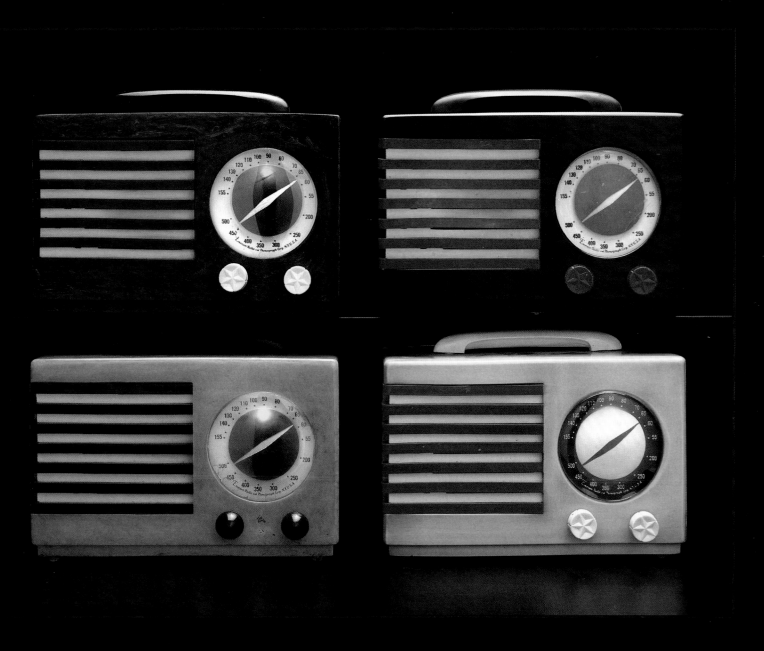

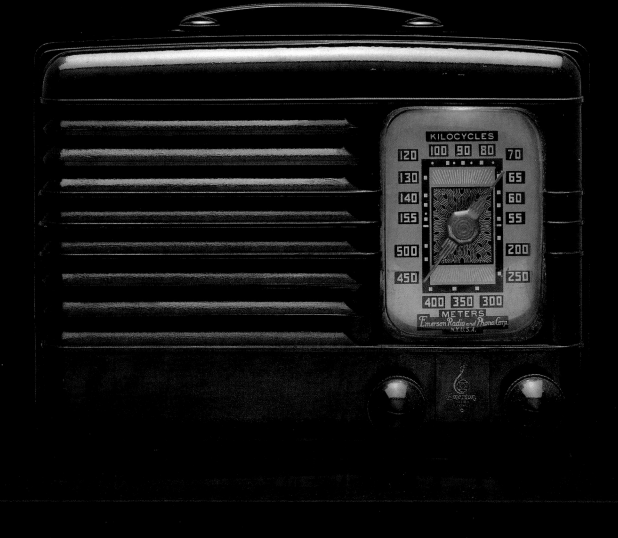

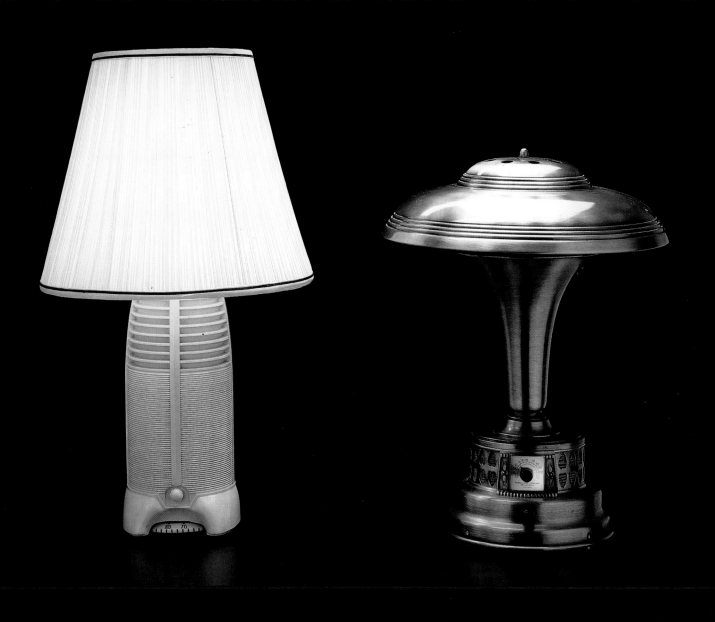

Mitchel "Lumitone" 1940 (left) and Radiolamp Corp. of America c. 1940 (right)

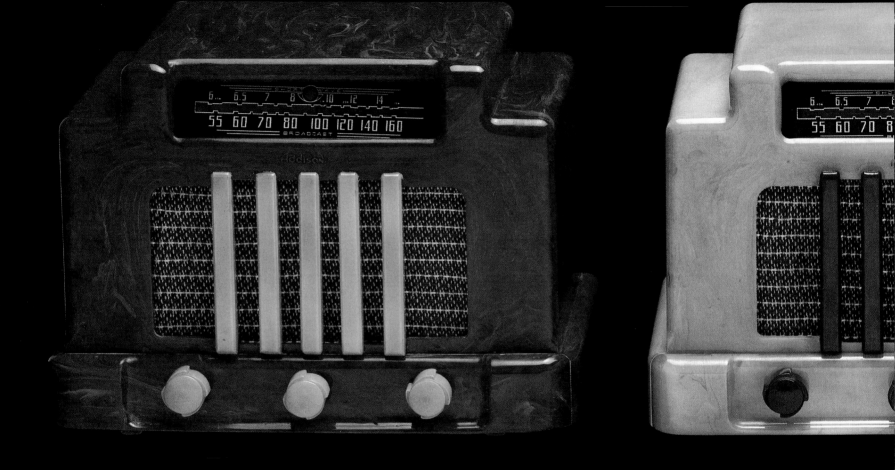

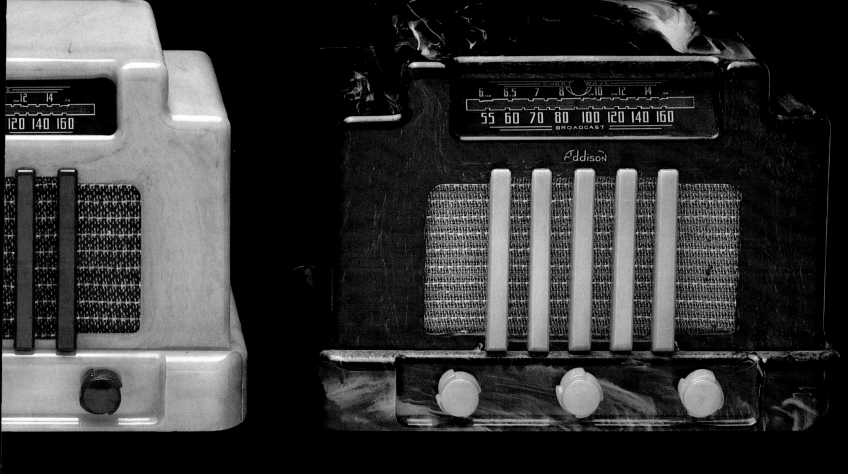

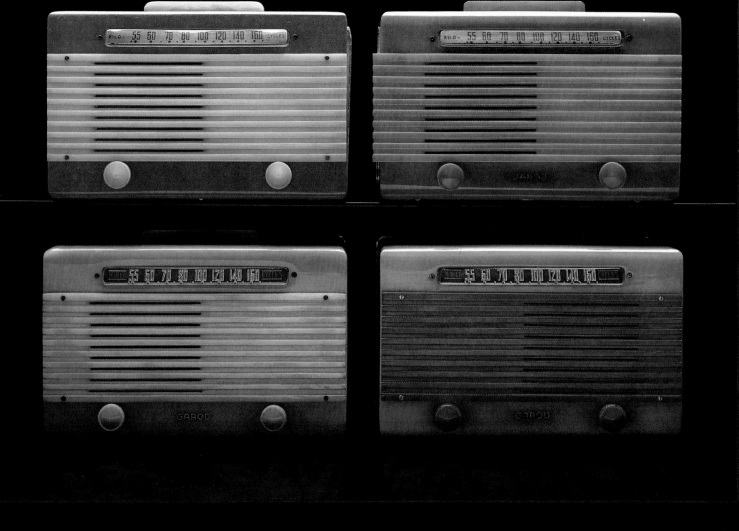

Garod "Commander" 1941

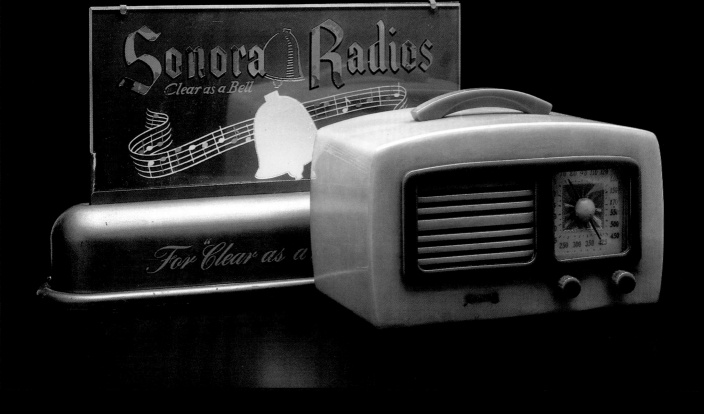

The New CROSLEY RADIOS for 1936

100 FEET PRICE $1

TALKING TAPE

TRADE MARK REG.

The Perfect Radio Aerial

HOPE

HOPE WEBBING CO.
For Forty Years
The World's Largest Manufacturers of Electric Tapes
PROVIDENCE, R. I.

DICK TRACY AND THE TIGER LILLY GANG

Radio PATROL
EDDIE SULLIVAN
CHARLIE SCHMIDT
THE BETTER LITTLE BOOK

CALLING W·1·X·Y·Z
Jimmy Kean and the RADIO-SPIES
THE BETTER LITTLE BOOK

SAMPSON
STIKTAPE AERIAL
INSTANTLY INSTALLED
"The EAR OF THE AIR"

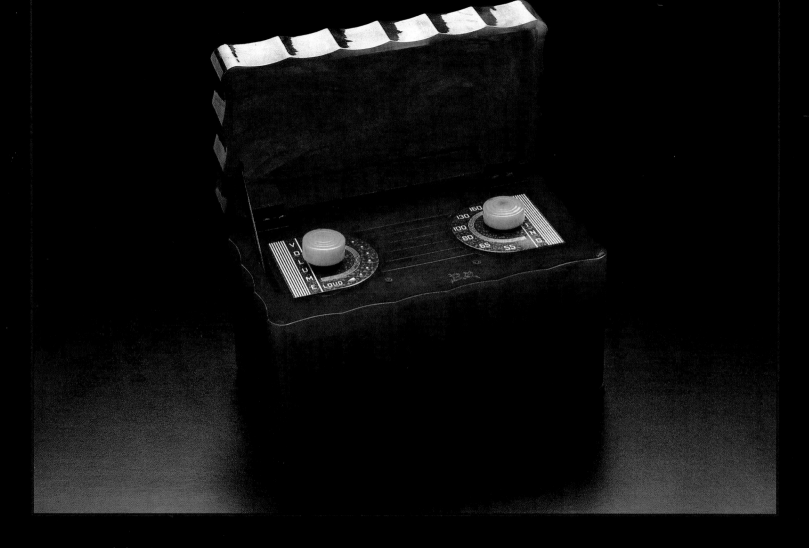

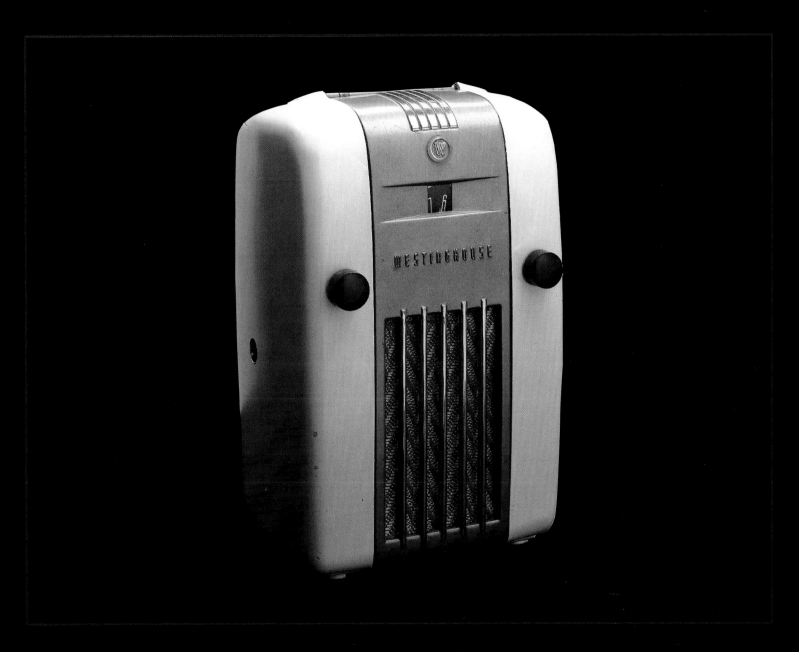

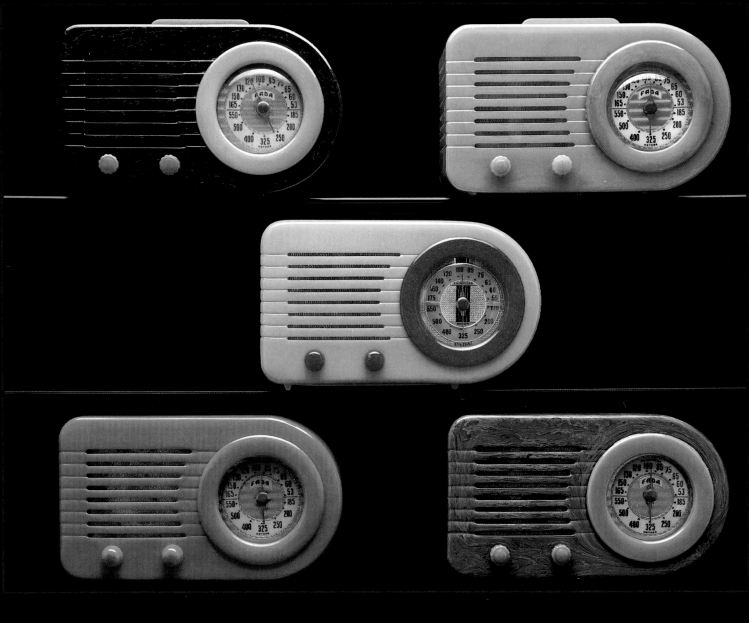

64 Fada "Streamliner" 1946 and 1941 (center)

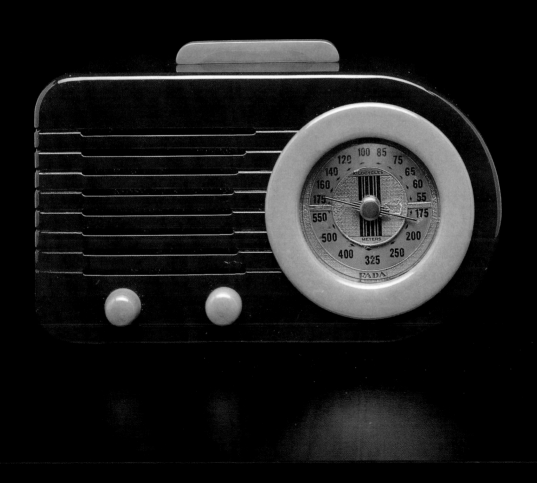

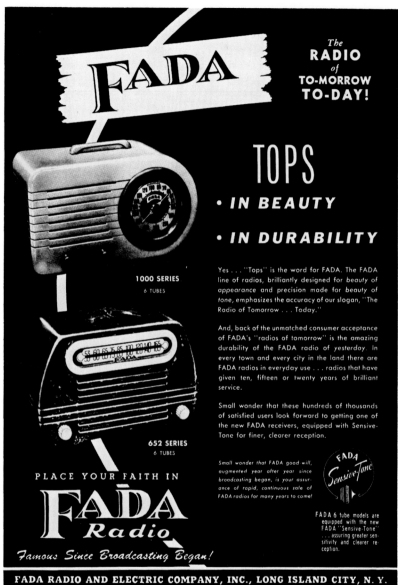

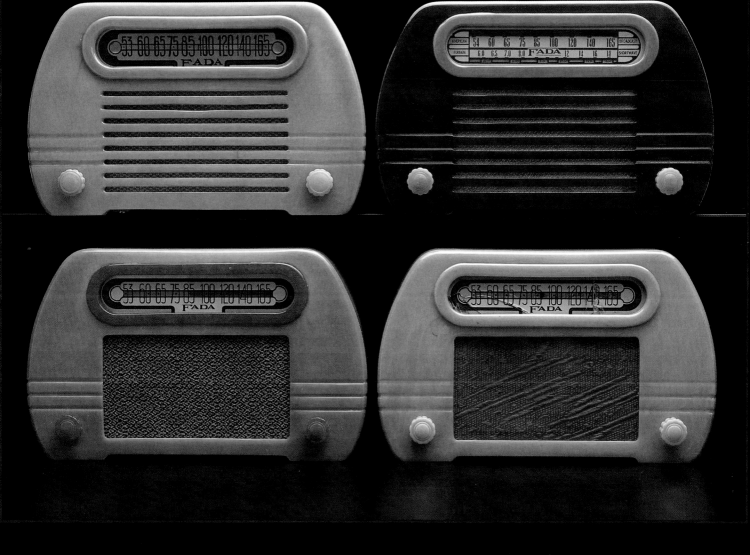

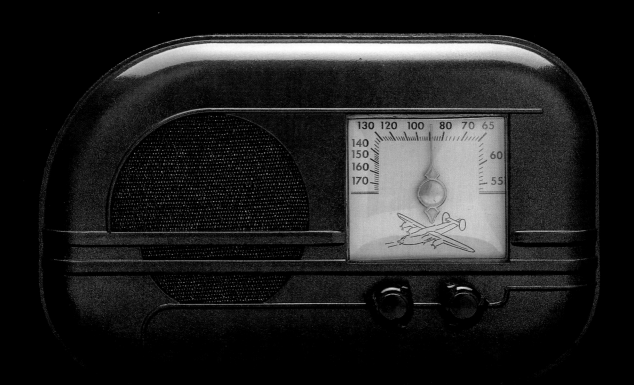

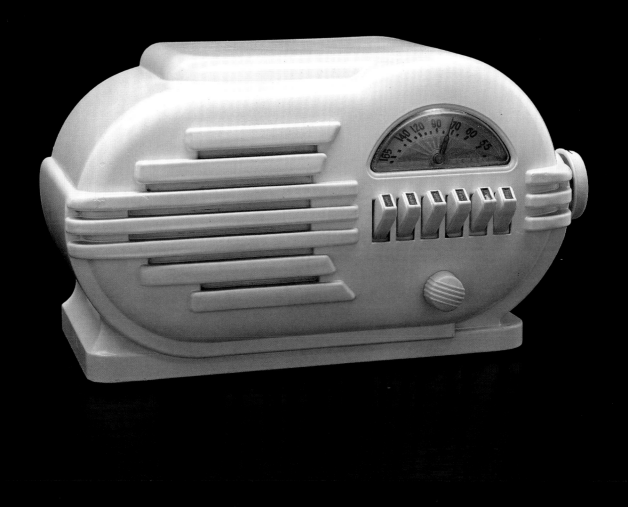

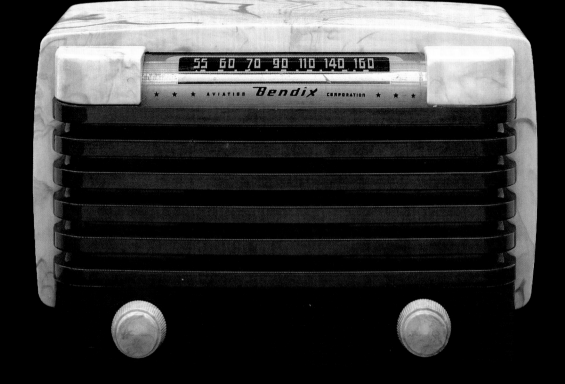

55 60 70 90 110 140 160

★ ★ ★ AVIATION *Bendix* CORPORATION ★ ★ ★

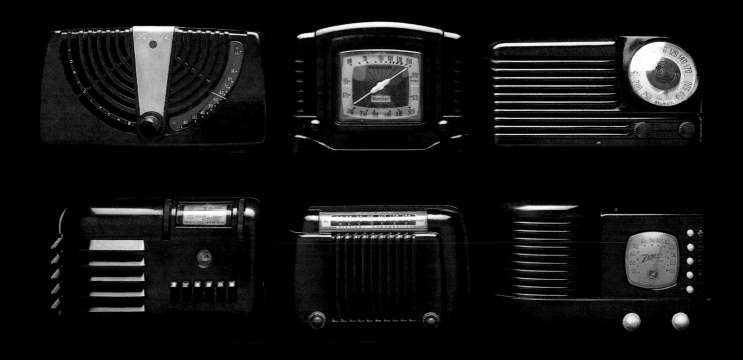

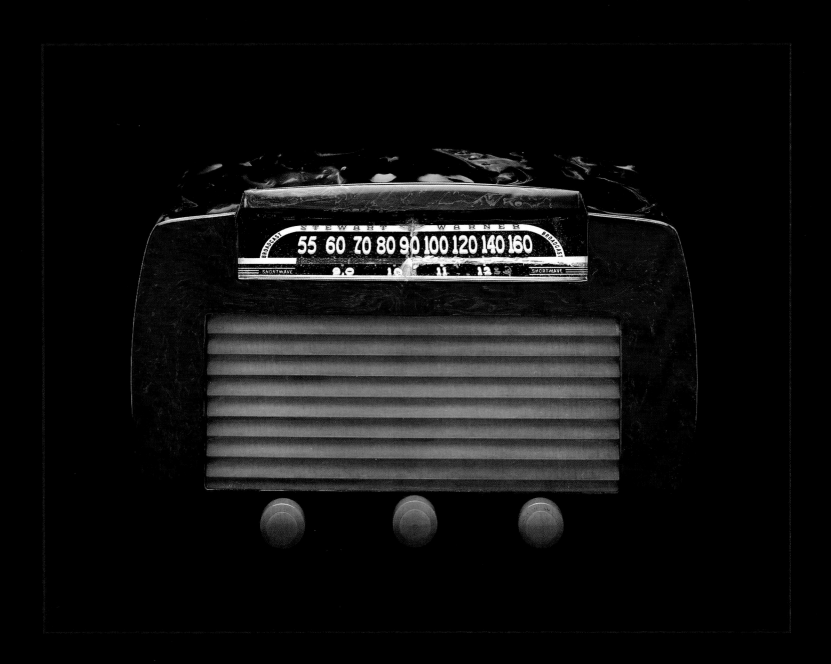

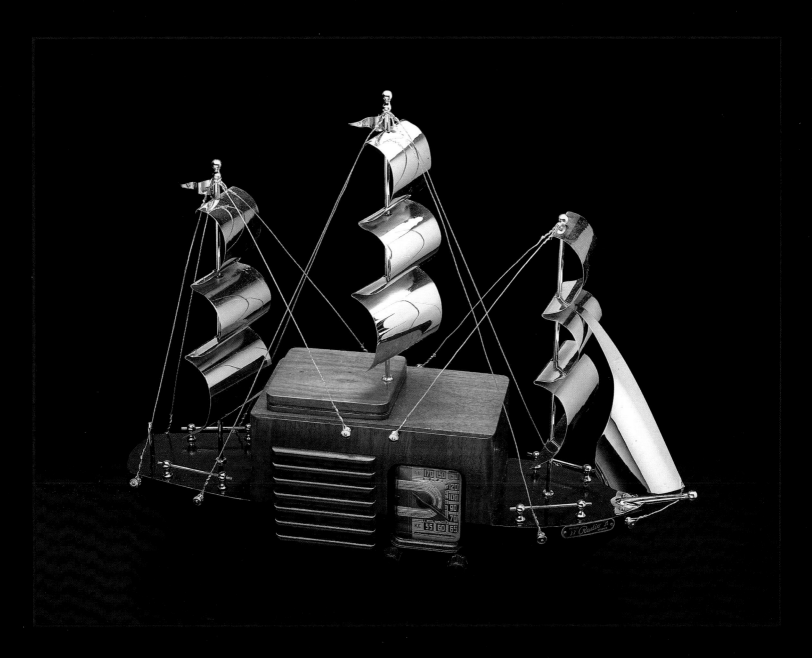

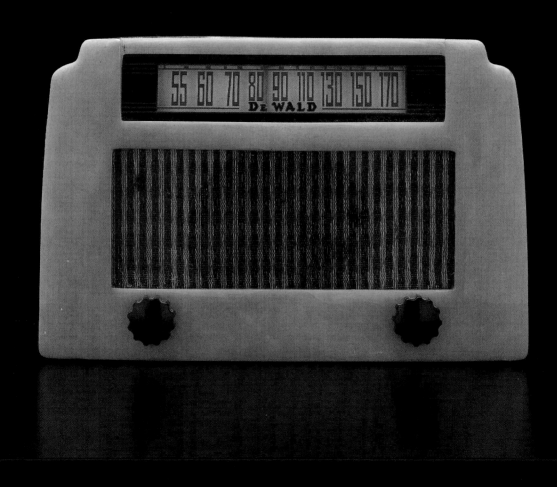

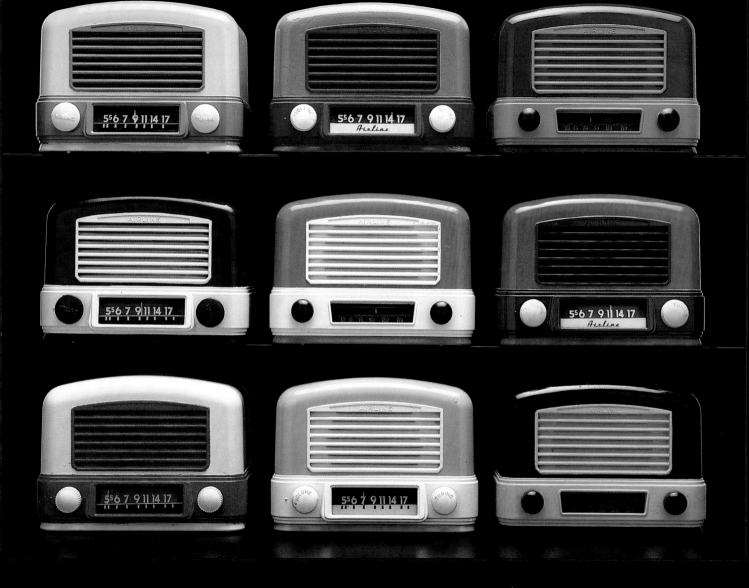

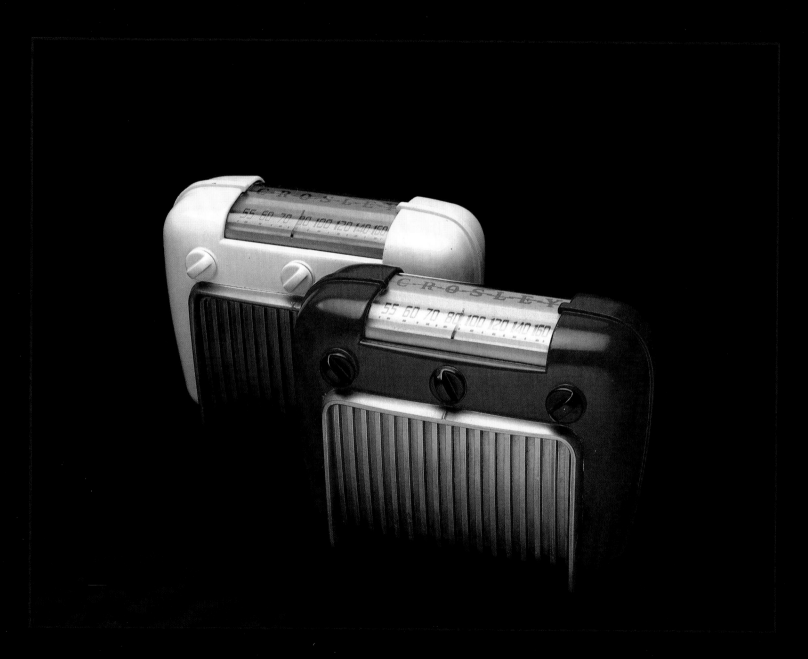

76 Crosley "Duette" 1946

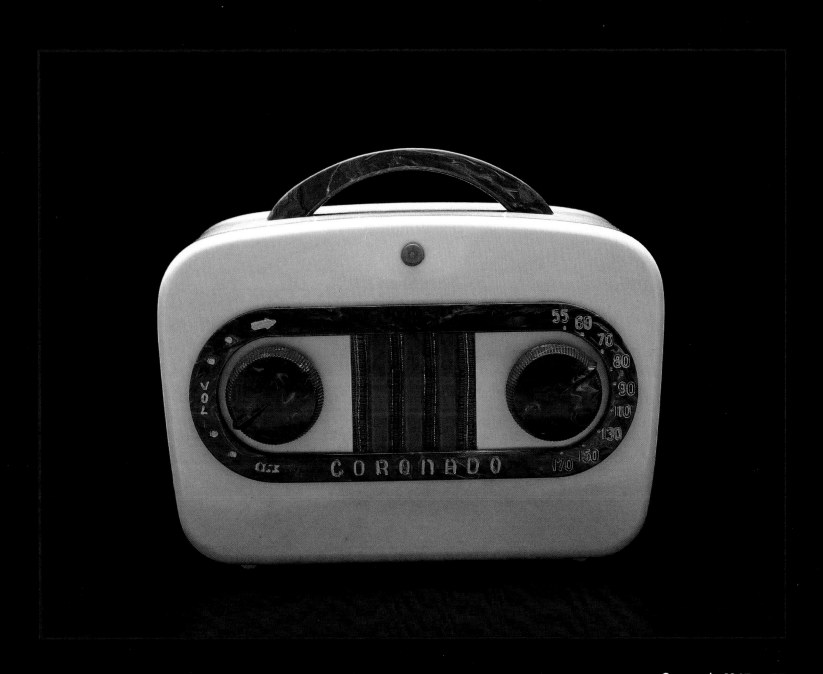

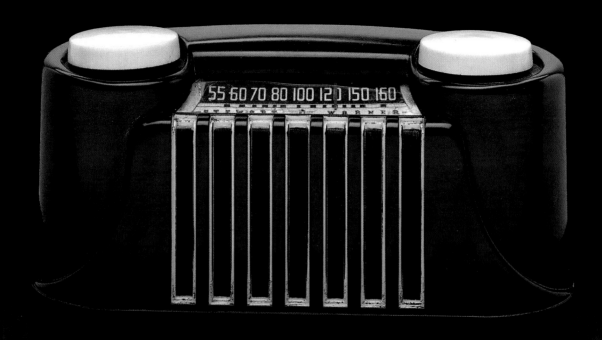

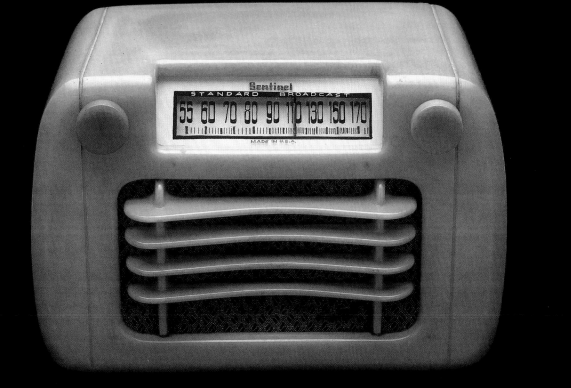

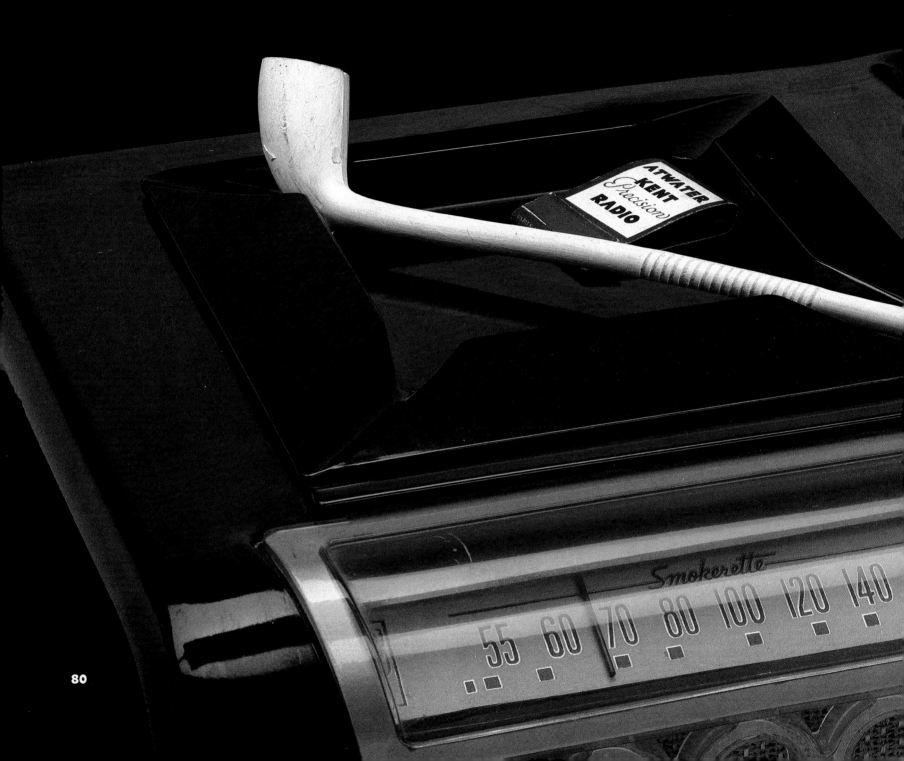

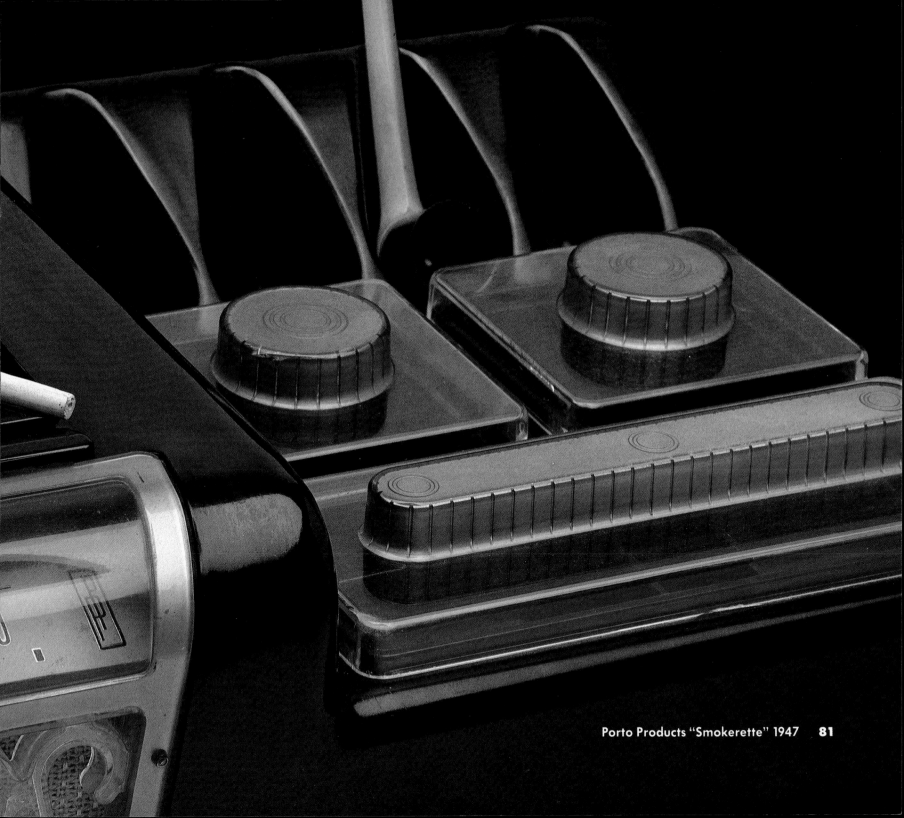

CROSSWORD PUZZLE

HORIZONTAL

1. 5. Star in the portrait (CBS, Thursday nights)
8. Felines
12. Thomas ——, English composer (1710-78)
14. Henry ——, singer
16. Ire
17. Meadow
19. One of the Great Lakes
20. Audibly
22. A warning of danger
24. Musical instrument
26. Alan ——, announcer
27. —— Stanley, bandleader
28. A company of musicians
30. Mountains in South America
33. A hook for fastening
37. Native inhabitant of New Zealand
38. Cleanse lightly with clean water
39. Dried plums
40. Joe ——, comedian
41. —— Fairchild, orchestra-leader
42. Animal allied to the weasel
45. —— Kent, radio actress
49. Extinct bird of New Zealand
51. Frances ——, radio actress
55. —— Levy, radio actress
57. Impart steadiness to
59. Be ready for
60. Worn over the top part of shoes
61. Imperfect
63. Time gone past
64. Top hat (slang)
67. Confederate
68. Certain
69. Lanny ——, tenor
70. —— Johnson, radio actress

VERTICAL

2. Masculine name
3. Bob ——, announcer
4. Feminine name
6. To dive under water, as whales
7. To rip
8. Restrain
9. Songs
10. Virginia Clark plays "Helen ——"
11. Crack, so as to let in water
13. Spanish article
14. To exist
15. A crescent
18. Facility
21. Jack ——, singer
22. Bow
23. A matrix
25. Werner ——, conductor
28. Willow tree
29. Land measure (pl.)
30. Unit of electrical measurement
31. Paul ——, announcer
32. Feminine name
34. Connection
35. Publications issued yearly
36. Weak cider
43. Postpone temporarily
44. Dashing effect
46. Pertaining to law
47. Country of Nino Martini's birth
48. A lizard
49. Substances fusible by heat
50. Take in, as a sponge
52. Male singing voice
53. Large-toothed files
54. A different one
56. Chinese measure
58. Initials of Arthur Peterson
61. Feminine name
62. Mexican tree
65. Nose like that of a bulldog
66. —— Maupin, orchestra-leader

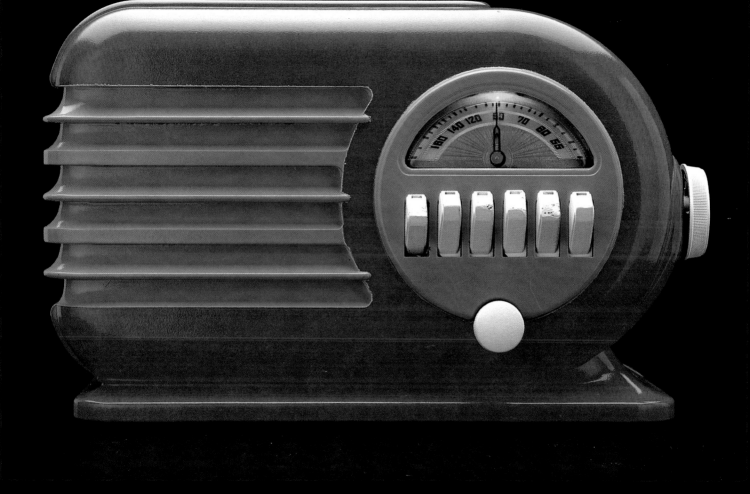

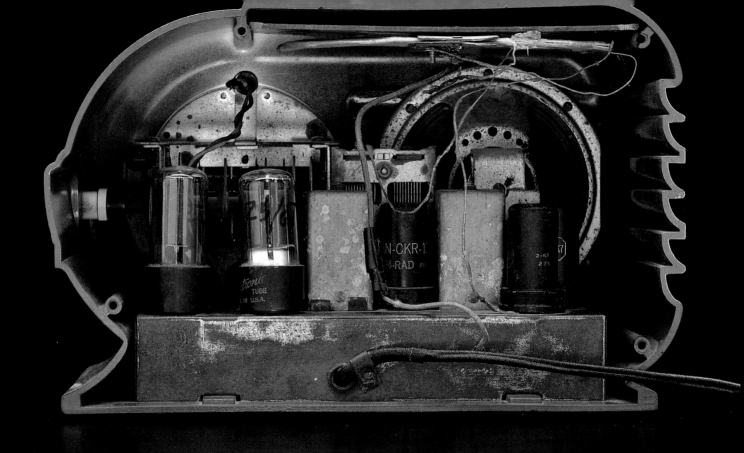

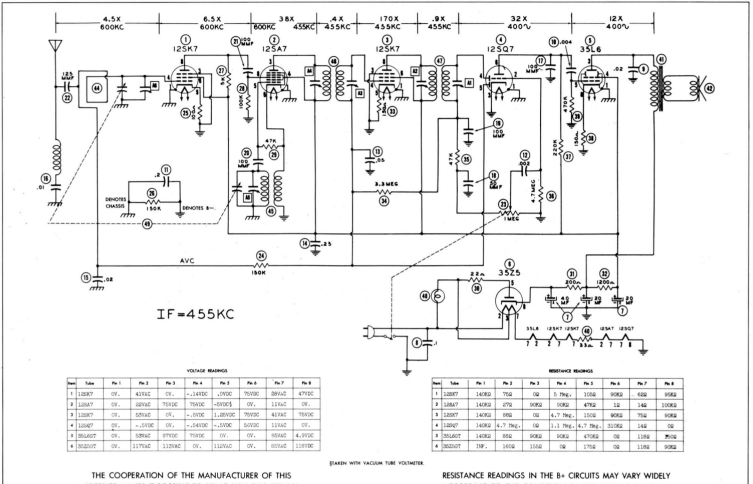

IF=455KC

VOLTAGE READINGS

Item	Tube	Pin 1	Pin 2	Pin 3	Pin 4	Pin 5	Pin 6	Pin 7	Pin 8
1	12SK7	0V.	41VAC	0V.	-.14VDC	.0VDC	75VDC	28VAC	47VDC
2	12SA7	0V.	22VAC	75VDC	75VDC	-5VDC§	0V.	11VAC	0V.
3	12SK7	0V.	53VAC	75VDC	-.5VDC	1.25VDC	75VDC	41VAC	75VDC
4	12SQ7	0V.	-.5VDC	0V.	-.54VDC	-.5VDC	56VDC	11VAC	0V.
5	35L6GT	0V.	53VAC	97VDC	75VDC	0V.	0V.	85VAC	4.9VDC
6	35Z5GT	0V.	117VAC	113VAC	0V.	112VAC	0V.	85VAC	118VDC

§TAKEN WITH VACUUM TUBE VOLTMETER.

RESISTANCE READINGS

Item	Tube	Pin 1	Pin 2	Pin 3	Pin 4	Pin 5	Pin 6	Pin 7	Pin 8
1	12SK7	140KΩ	75Ω	0Ω	5 Meg.	105Ω	90KΩ	62Ω	95KΩ
2	12SA7	140KΩ	27Ω	90KΩ	90KΩ	47KΩ	1Ω	14Ω	100KΩ
3	12SK7	140KΩ	88Ω	0Ω	4.7 Meg.	150Ω	90KΩ	75Ω	90KΩ
4	12SQ7	140KΩ	4.7 Meg.	0Ω	1.1 Meg.	4.7 Meg.	310KΩ	14Ω	0Ω
5	35L6GT	140KΩ	88Ω	90KΩ	90KΩ	470KΩ	0Ω	118Ω	150Ω
6	35Z5GT	INF.	160Ω	155Ω	0Ω	175Ω	0Ω	118Ω	90KΩ

THE COOPERATION OF THE MANUFACTURER OF THIS
RECEIVER MAKES IT POSSIBLE TO BRING YOU THIS SERVICE

A PHOTOFACT STANDARD NOTATION SCHEMATIC
© Howard W. Sams & Co., Inc. 1947

The stage gain measured values listed above are approximate values for an average operative stage, rather than an absolute value. It should be borne in mind that it is possible to introduce so many variables into the measurement operation, such as, type of equipment used for measuring, handling and placement of probes, the accuracy of alignment, etc., that an absolute reading is impractical. AVC is made inoperative and 3-volt battery bias substituted for measurement.

RESISTANCE READINGS IN THE B+ CIRCUITS MAY VARY WIDELY
ACCORDING TO THE CONDITION OF THE FILTER CAPACITORS

4714-12

1. DC Voltage measurements are at 20,000 ohms per volt; AC Voltages measured at 1,000 ohms per volt.
2. Socket connections are shown as bottom views.
3. Measured values are from socket pin to common negative.
4. Line voltage maintained at 117 volts for voltage readings.
5. Nominal tolerance on component values makes possible a variation of ± 10% in voltage and resistance readings.
6. Volume control at maximum, no signal applied for voltage measurements.

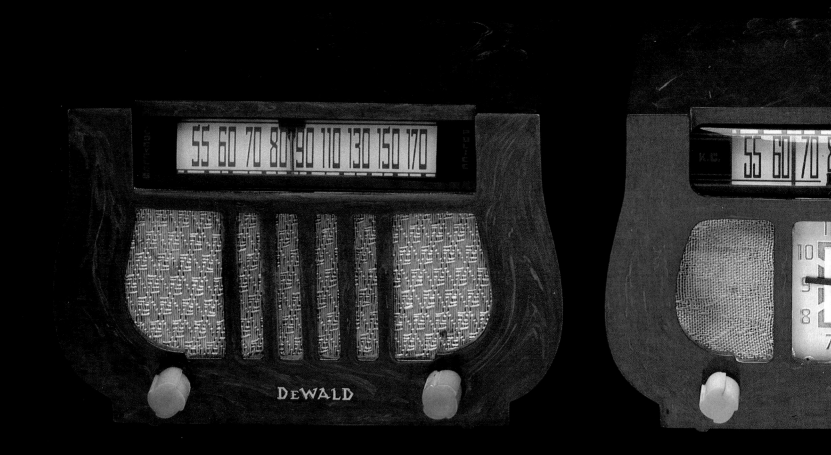

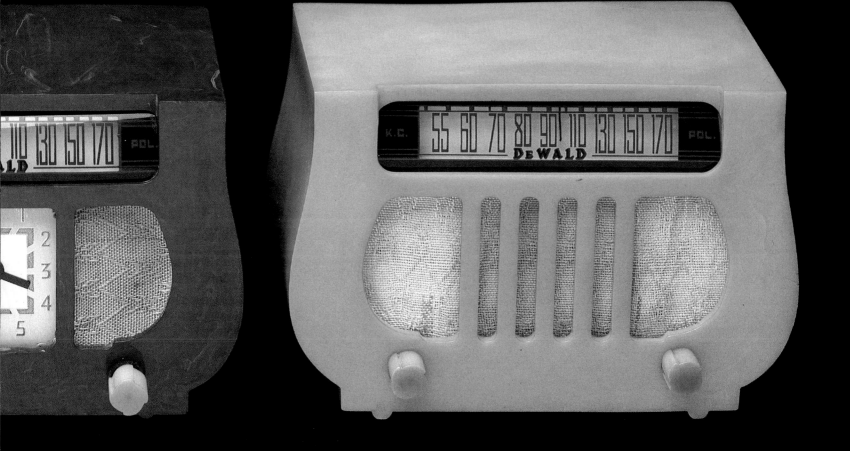

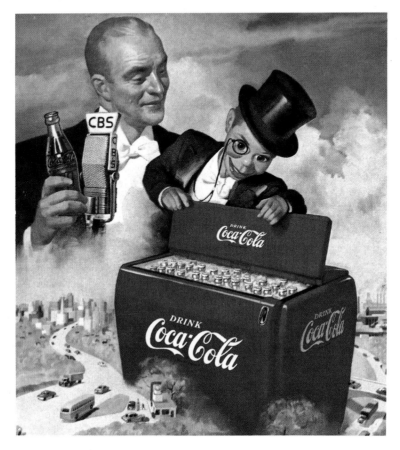

YOUR HOST OF THE AIRWAVES

The Coca-Cola Company presents

EDGAR BERGEN with CHARLIE McCARTHY
CBS 8 p. m. EST every Sunday

And every day...wherever you travel, the familiar red cooler is your
HOST OF THE HIGHWAYS...HOST TO THE WORKER in office
and shop...HOST TO THIRSTY MAIN STREET the country over.

HI PARDNER---
PROUD TO HAVE YOU JOIN UP

Quite a radio you have here. It's made specially for young cow pokes and cow gals who know something good when they see it. Now, let me tell you about it.

First thing, it'll play on either AC or DC power. It's not persnickety so long as the juice is between 105 and 115 volts. And it doesn't take a whole lot of juice either—only 30 watts (about half as much as an ordinary light bulb).

It's a mighty tough radio, too, with a solid steel case and a real rugged chassis. It can take real rough treatment if it has to—but then there isn't any point in treatin' it mean just because of that. Incidentally, it's Underwriters' Laboratories listed, too. That means it's been tested all kinds of ways and it's safe!

NOW YOU'RE READY TO SADDLE UP

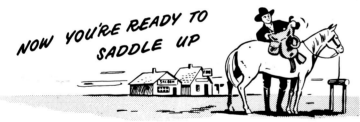

It doesn't make much difference where you set it, but it's best to keep it off the radiator or heater. Now, unwind the power cord and plug it in. If your bunk-house has AC current you can put the plug in either way and it will play. (Sometimes it will play better if you pull the plug out and turn it over and plug it back in. You can find out which way is best by trying both ways.) If you have DC current your radio will play with the plug pushed in just one way. So, if you're using DC and your radio doesn't work the first time you plug it in, pull out the plug and turn it over and plug it in the other way.

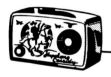

NOW UNCOIL THE LARIATENNA

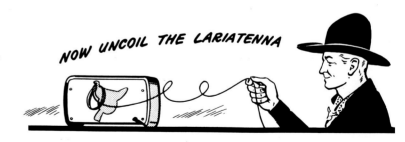

On the back of the radio, all coiled up and hung on the pommel of the saddle is your antenna. We call it the "Lariatenna" and if you use it like I tell you, you can rope in more stations than you can stuff in a ten gallon hat. Here's how.

★ Take the Lariatenna off the saddle pommel.
★ Unwind it—clear out.
★ Stretch it out along the wall of the bunk-house. Not too tight.
★ Attach the suction cup to the window glass—or the bunk-house wall if Mom will let you.
★ That's all.

Most places, you won't need all the 20 feet of the Lariatenna strung out. Maybe only a third of it or half of it. Coil what you don't need back on the saddle pommel.

When you string out the "Lariatenna," keep it close to the wall and out of the way. Keep it out of the middle of the bunk-house or you may get your spurs all tangled up in it and pull the radio off the table. And it will keep the women-folk happier if everything's neat. And, listen, Pardner, don't attach the "Lariatenna" to a water pipe, or radiator or the like. Those things are what they call "grounded" and this radio is designed to operate without ground connection.

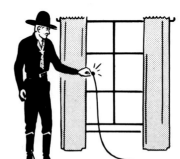

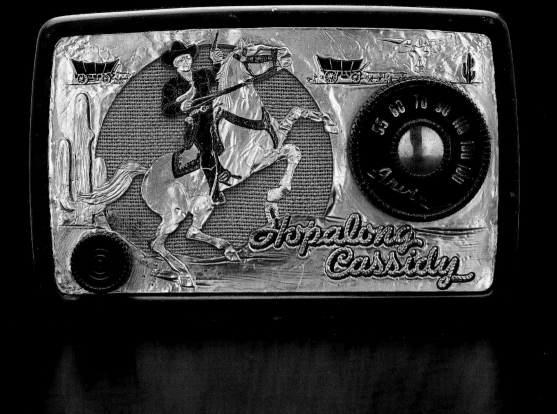

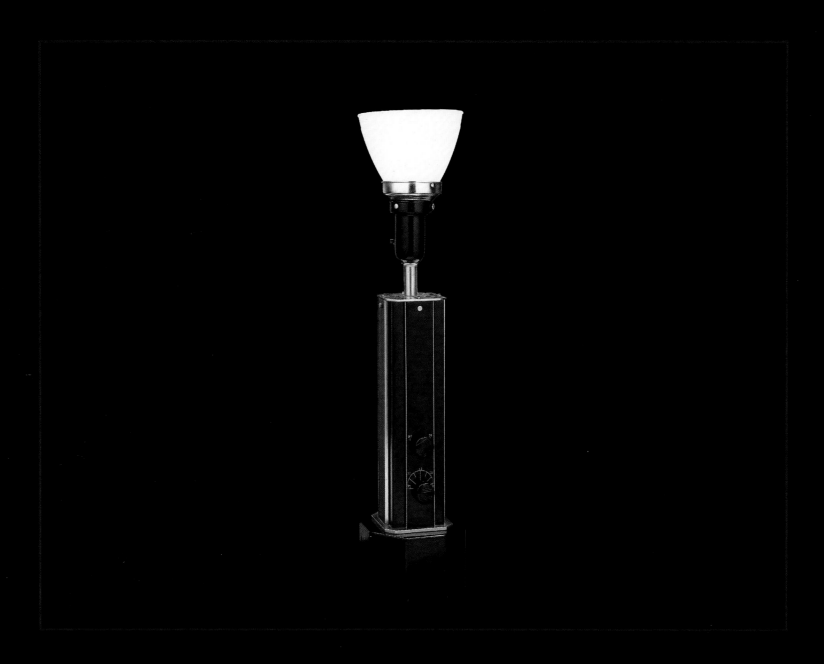

92 Unknown c. 1950

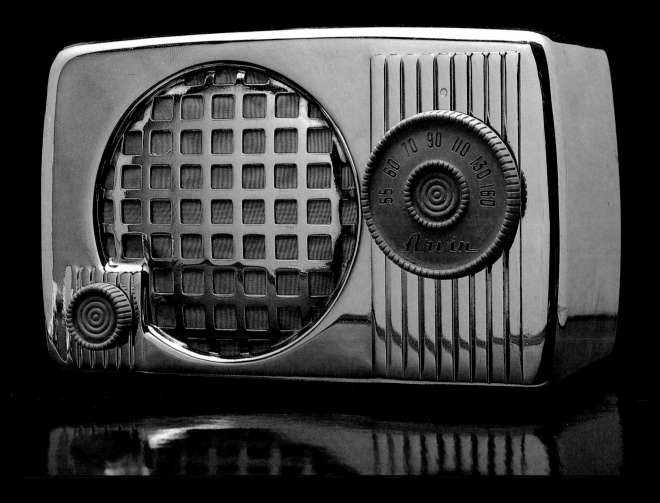

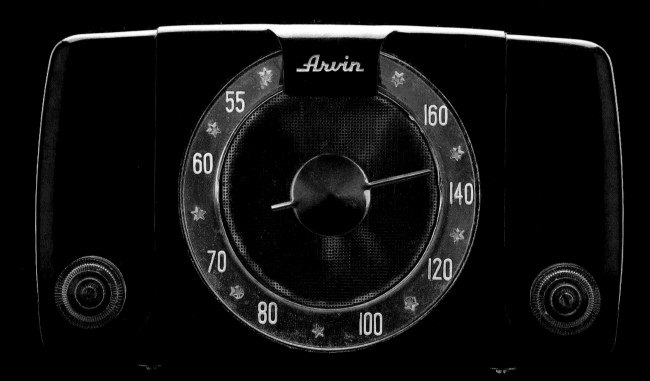

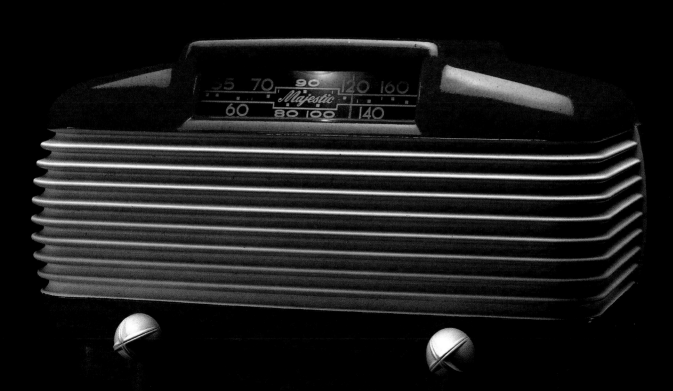

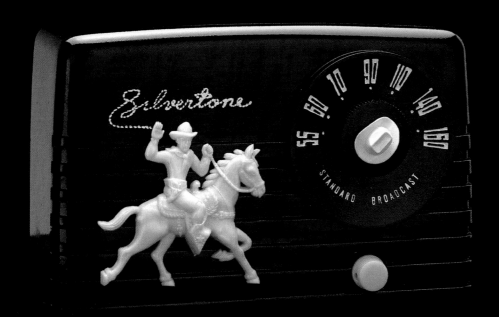

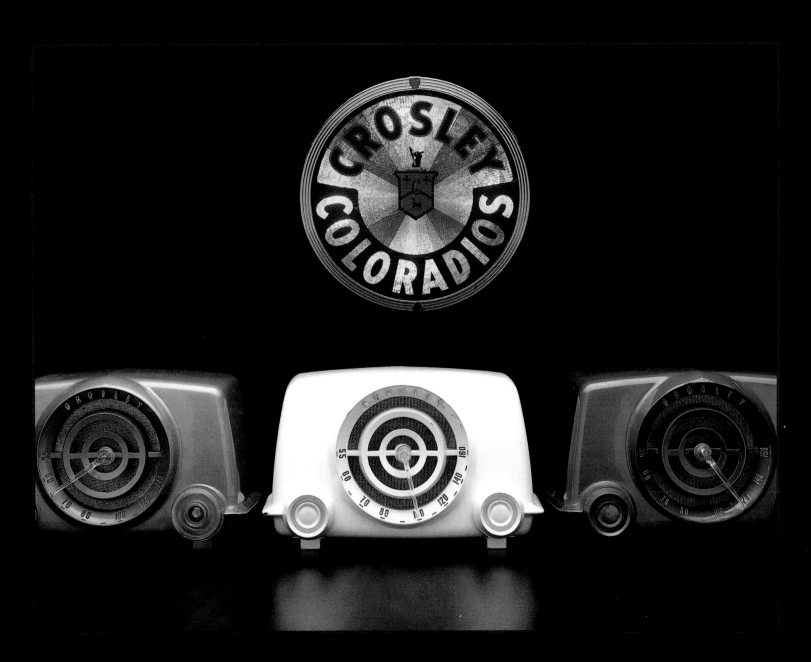

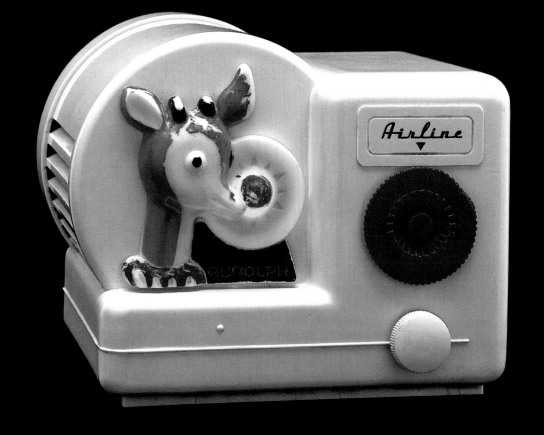

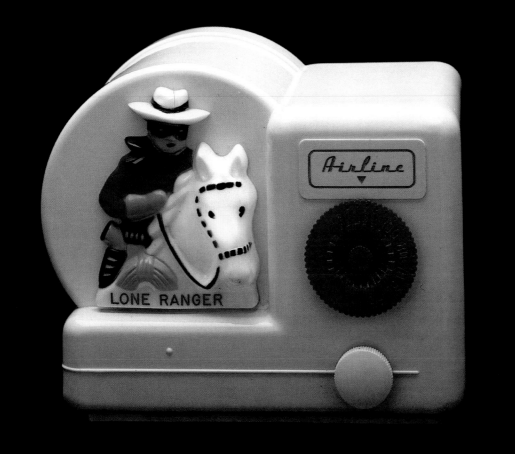

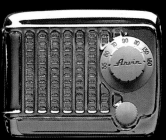
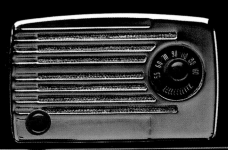
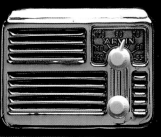
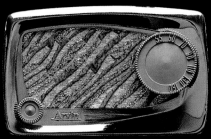
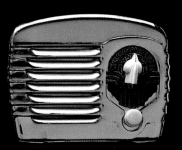
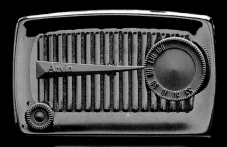
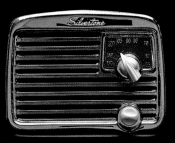
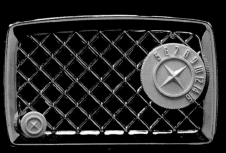

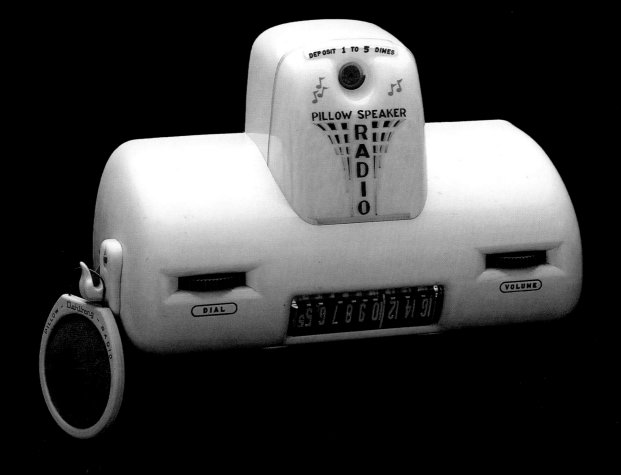

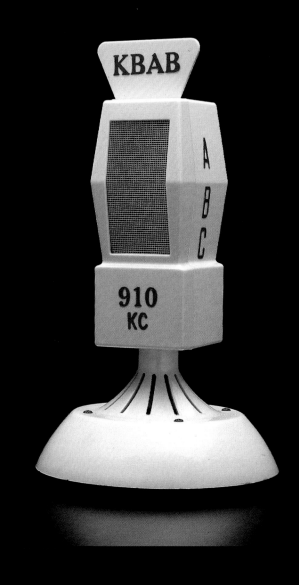

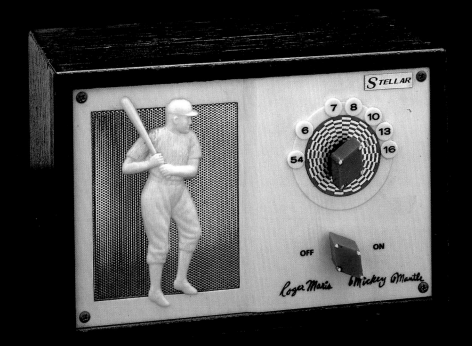

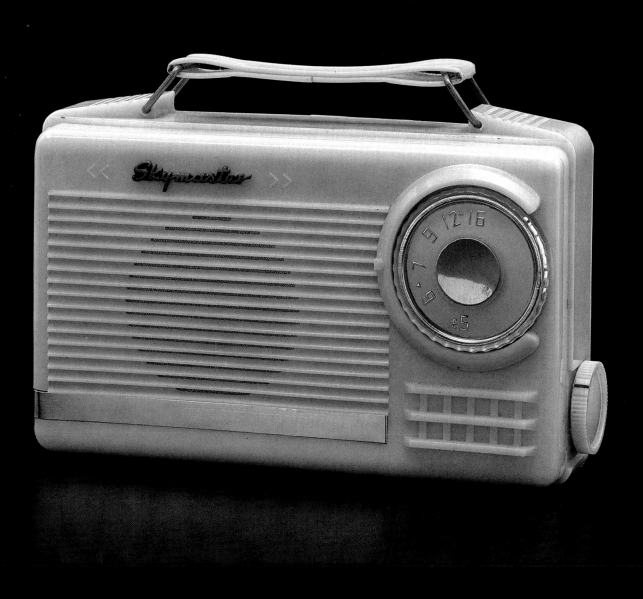

NOTES:

Unless otherwise stated, cabinets are manufactured by compression molding in a variety of plastic compounds, mainly Phenol Formaldehyde (Bakelite, Catalin), Urea, and Casein.

The dates refer to the first year of public sale.

The onset of World War II interrupted innovation and production. On their return to post war production in 1946, many companies marketed models originally designed for sale in 1943 and 1944. They also added a new series of designs.

Cosmetic features were sometimes changed, unannounced, altering model numbers of similar sets in a particular range. These vaguaries are often the source of heated debate among the hardened radio collecting fraternity. A changed knob here . . . a revised dial face there — the variety of design between 1932 and 1955 is practically infinite.

The dating and identification of model numbers is based upon original information supplied by manufacturers that has often proved contradictory, however, these discrepancies do not detract from the enjoyment of this golden era in American radio design.

PHOTOGRAPHER'S NOTES:

The radios were photographed with a 4x5 inch view camera, through a 215 mm lens onto 4x5 inch transparency film. Although each set required special lighting for its own unique features, the main light source was a large soft box placed over the subject. An aperture of F/32 was used, and ambient exposures sometimes ranged up to six minutes to capture the faintly lit dials. *Robert Patterson*

"A RADIO FOR EVERY ROOM"

12/13 Emerson
Left: "Mickey Mouse"
Model 411: 1933
Syroco wood
Original condition
Jerry Simpson Collection

Right: "Mickey Mouse"
Model 410: 1933
Wood, metal trim
Refinished
Jerry Simpson Collection

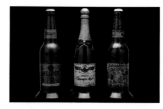

17 Unknown *Model C-500: 1934*
Left: Refinished
Jerry Simpson Collection

Center and right:
Original condition
Philip Collins Collection

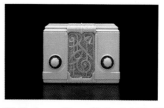

21 Kadette *"Jewel" Model 43: 1935*
Designed by Gardiner Vess
Original condition
Doug Heimstead Collection

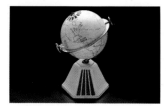

15 Colonial *"New World:" 1933*
Original condition
Courtesy Off the Wall, Melrose Avenue, Los Angeles

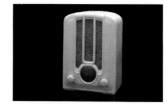

18 Emerson *Model U5A: 1935*
Original condition
Philip Collins Collection

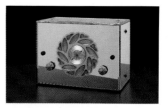

24 Unknown: *c.1935*
Mirrored
Original condition
Gary Hough Collection

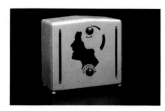

16 Stewart Warner: *1933*
Metal
Original condition
Doug Heimstead Collection

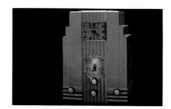

19 Air King: *1935*
Designed by Harold L. Van Doren
and J.G.. Rideout
Refinished
Jerry Simpson Collection

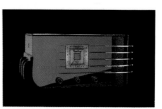

25 Sparton *Model 517: 1936*
Designed by Walter Dorwin Teague
Mirror, chrome, and wood
Refinished
Jerry Simpson Collection

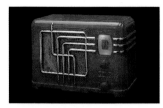

27 Fada *Model 254: 1937*
Original condition
Ed and Irene Ripley Collection

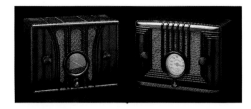

30/31 Emerson
Left: Model 109: 1935
Original condition
Doug Heimstead
Collection

Right: Model BA 199: 1938
Original condition
Philip Collins Collection

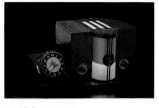

34 Airite: *1938*
Original condition
Mike Adams Collection

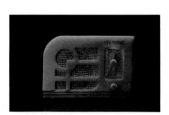

28 Tom Thumb: *1938*
Original condition
Philip Collins Collection

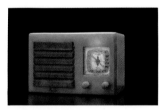

32 Fada: *1938*
Original condition
Philip Collins Collection

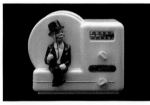

35 Majestic *"Charlie McCarthy" Model 1: 1938*
Metal and bakelite
Refinished
Jerry Simpson Collection

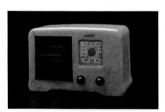

29 Emerson *Model AX 235: 1938*
Original condition
Bill Kaplan Collection

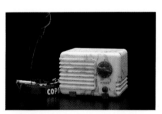

33 Detrola *"Peewee": 1938*
Designed by George Walker
Original condition
Doug Heimstead Collection

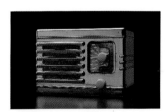

36 Unknown *c.1938*
Metal, chromed
Refinished
Philip Collins Collection

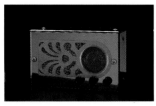

37 Troy *Model 45-M: 1938*
Mirrored
Original condition
Jerry Simpson Collection

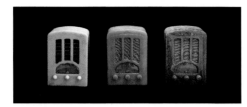

40/41 Emerson
Left: Model BT 245: 1939
Center: Model AU 190: 1938
Right: Model AU 190: 1938
All original condition
Mark Honea Collection

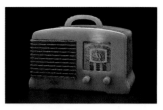

45 Fada *Model L 56: 1939*
Original condition
Barry and Ellen Blum Collection

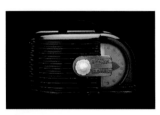

38 Zenith *Model 6D315U: 1938*
Refinished
Philip Collins Collection

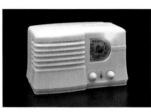

42 Emerson: *c.1939*
Original condition
Philip Collins Collection

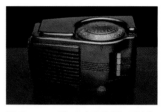

47 Sonora *Model TW 49: 1939*
Original condition
Steve Camargo Collection

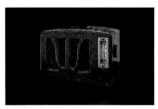

39 RCA: *c.1938*
Original condition
Jerry Simpson Collection

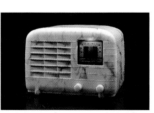

43 General Electric *Model H-600: 1939*
Original condition
Philip Collins Collection

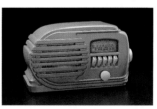

48 Belmont *Model 534: 1940*
Refinished
Philip Collins Collection

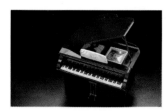

49 Continental: *c.1940*
Original condition
Ed and Irene Ripley Collection

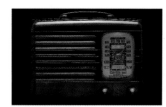

54 Emerson *Model EC301: 1940*
Original condition
Philip Collins Collection

58 Garod *"Commander"*
Model 6AU-1: 1941
All original condition
Mark Honea Collection

50/51 Addison *Model A2A: c.1940*
Original condition
Mark Honea Collection

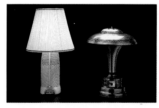

55 *Left:* **Mitchel** *"Lumitone" Model 1260: 1940*
Original base
Philip Collins Collection

Right: **Radiolamp Corporation of America:**
c.1940 Refinished
Jerry Simpson Collection

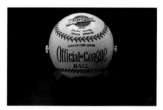

59 Trophy: *c.1941*
Molded cardboard
Refinished
Jerry Simpson Collection

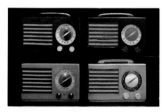

53 Emerson *"Patriot" and "Aristocrat"*
Model 400: 1940
Designed by Norman Bel Geddes
All original condition
Philip Collins Collection
Bottom row left: Mark Honea Collection

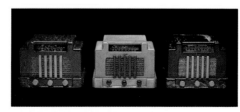

56/57 Addison *Model 5F: c.1940*
All original condition
Mark Honea Collection

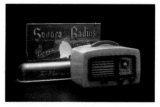

60 Sonora *"Coronet" Model KM: 1941*
Original condition
Mark Honea Collection

62 General Electric *Model L-622: 1941*
Original condition
William Cawlfield Collection

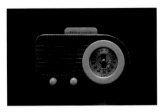

65 Fada *"Streamliner" Model 115: 1941*
Original condition
Philip Collins Collection

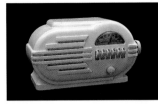

69 Belmont *Model 6D 111: 1946*
Refinished
Philip Collins Collection

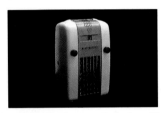

63 Westinghouse *"Little Jewel" Model H 124: 1945*
Original condition
Philip Collins Collection

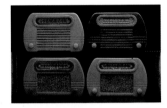

67 Fada *Model 652: 1946*
Top right: Model 252
All original condition
Refinished grill cloths
Mark Honea Collection
Top row, left: Philip Collins Collection

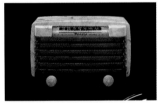

70 Bendix *Model 115: 1946*
Original condition
Philip Collins Collection

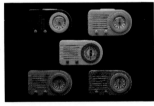

64 Fada *"Streamliner" Model 1000: 1946*
Center row: Model 115: 1941
All original condition
Mark Honea Collection

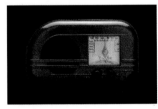

68 Unknown: *c.1946*
Refinished
Philip Collins Collection

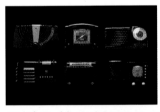

71 *Left:* **Zenith *Model 6DO 15: 1946***
Airline *Model 93 WG 604A: 1946*
Center: **Trutone *Model D 2661: c. 1946***
Bendix *Model 0516A: 1946*
Right: **Olympic *Model 6-501: 1946***
Zenith *Model 5R312: 1938*
All original condition Phillip Collins Collection

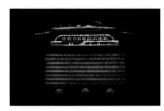

72 Stewart Warner *Model 62T36: 1946*
Original condition
Mark Honea Collection

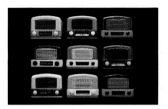

75 Airline: *c.1946*
Left: 64BR-1501A 64BR-1501A 64BR-1501A
Center: 84BR-1502B 4BR-511A 84BR-1502B
Right: 4BR-511A 84BR-1502S 4BR-511A
All models refinished
Philip Collins Collection

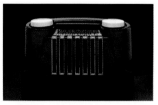

78 Stewart Warner *"Air Pal" Model A51T3: 1947*
Refinished grill cloth
Philip Collins Collection

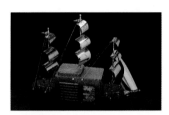

73 Majestic *"Melody Cruiser" Model 921: c.1946*
Wood and chrome
Refinished
Clyde Plott Collection

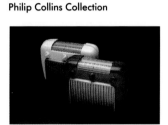

76 Crosley *"Duette" Model 56 TD: 1946*
Refinished
Philip Collins Collection

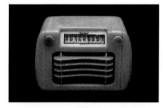

79 Sentinel *Model L-284: 1947*
Original condition
Mark Honea Collection

74 DeWald *Model A502: 1946*
Original condition
Courtesy Harvey's; Melrose Avenue, Los Angeles

77 Coronado *Model 43-8190: 1947*
Original condition
Mark Honea Collection

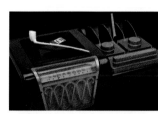

80/81 Porto Products *"Smokerette": 1947*
Designed by Barnes & Reinecke
Original condition
Philip Collins Collection

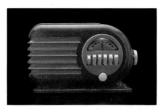

83 Belmont *Model 6D120: 1947*
Refinished
Philip Collins Collection

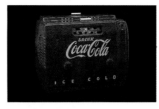

89 Point of Purchase Displays, Inc.
"Coca-Cola Cooler"
Model 5A 410A: 1949
Refinished
Jerry Simpson Collection

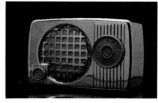

93 Arvin *Model 440-T: 1950*
Chromed
Refinished metal
Philip Collins Collection

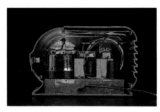

84 Behind the Painted Smile

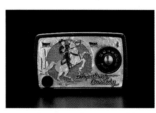

91 Arvin *"Hopalong Cassidy" Model 441-T: 1950*
Original condition
Philip Collins Collection

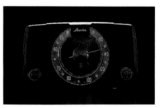

94 Arvin *Model 541 TL: 1950*
Original condition
Philip Collins Collection

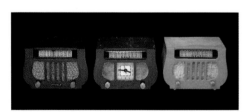

86/87 DeWald
Left: Model A-501: 1941. Philip Collins Collection
Center: Model B-403: 1948. Mark Honea Collection
Right: Model B-501 UL: 1941. Mark Honea
Collection
All in original condition

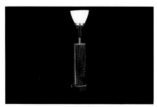

92 Unknown: *c.1950*
Brass and metal
Refinished
Jerry Simpson Collection

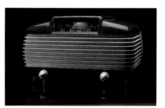

95 Majestic *Model 5 LA 5: 1951*
Refinished
Philip Collins Collection

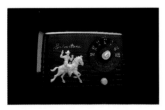

96 Silvertone *Model 4:233: 1951*
Refinished
Jerry Simpson Collection

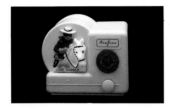

99 Airline *"Lone Ranger" Model 05GCB-1541: 1951*
Original condition
Ed and Irene Ripley Collection

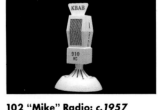

102 "Mike" Radio: *c.1957*
Original condition
Bob Breed Collection

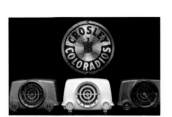

97 Crosley
Left: Model D10TN: 1951
Center: Model 11 100U: 1951
Right: Model 11 102U: 1951
All in original condition
Barry and Ellen Blum Collection

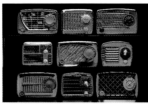

100 Arvin and Silvertone *Left:* Arvin Model 842J: 1947
Arvin Model 444: 1946 Arvin 840T: 1954
Center: Arvin Model 242T: 1948 Arvin: c.1955
Silvertone Model 6002: 1946 *Right:* Arvin Model 422A
Silvertone: c.1949 Silvertone Model 1: 1950
Refinished metal and chrome Philip Collins Collection

103 Stellar *"Mickey Mantle:" c.1959*
Japanese
Wood cabinet
Original condition
Philip Collins Collection

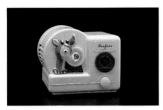

98 Airline *"Rudolph:" 1951*
Original condition
Ed and Irene Ripley Collection

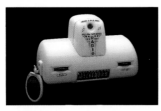

101 Dahlberg *"Pillow Speaker Radio" Model 430-D1: c.1955*
Note the inverted dial for the convenience
of the reclining listener
Original condition
Courtesy Harvey's, Melrose Avenue, Los Angeles

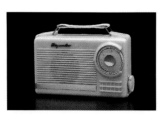

105 Sky Master *Model PR 530: c.1957*
Original condition
One of the last models to utilize 'peanut' tubes
Philip Collins Collection

COLLECTORS:

Grateful thanks are due to the following collectors:

Mike Adams
(714) 779-7907
Collecting wood, console and plastics
Complete restoration of wood radios

Barry and Ellen Blum
(213) 274-6662
Collecting all plastics and novelty

Charles Bradley
(612) 888-7437
Collecting radio memorabilia

Bob Breed
(619) 274-0712
Collecting novelty and transistor novelty

Steve Camargo
3730 1st. Avenue #7
San Diego, Ca. 92103
Collecting plastics

William Cawlfield
(818) 368-9060
Collecting plastics and novelty
Restoration of all sets

Philip Collins
(213) 479-0167
Collecting Catalin, bakelite, mirrored, metal and novelty

Doug Heimstead
(612) 571-1387
Collecting mirrored, plastics and televisions
Restoration and repair of radios and televisions

Mark Honea
(816) 891-2441
Collecting catalin, mirrored and novelty

Gary Hough
(714) 835-5765
Collecting vintage TV's, mirrored and catalin radios

Bill Kaplan
(213) 379-3399
Collecting wood console and table
Complete restoration and repair

Joe Knight
(213) 831-5556
Collecting anciliary radio artefacts and memorabilia

Clyde Plott
(805) 255-4600
Collecting wood table and console

Ed and Irene Ripley
(612) 777-6791
Collecting plastics, wood, novelty and mirrored

Jerry Simpson
(805) 251-7829
Collecting wood, novelty, plastics and mirrored
Complete restoration of all sets

BIBLIOGRAPHY:

Radio Retailing Magazine: 1937-39

Radio & Television Retailing Magazine: 1939-41

Radio Guide Magazine: 1939

Volksempfanger by Dieter Holtschmidt: 1981

The Cat's Whisker by Jonathan Hill, Oresko Books Ltd.: 1978

Dime-Store Dream Parade by Robert Heide and John Gilman, E.P. Dutton: 1979

Gli Anni di Plastica by Pasquale Alferj and Franscesca Cernia, Electa: 1983

Art Plastic by Andrea DiNoto, Abbeville: 1984

Plastics by Sylvia Katz, Thames & Hudson: 1984

Small Radio, Emerson Radio & Phonograph Corp.: 1943

Radio for the Millions, Popular Science Publishing Co.: 1945

Industrial Design by John Heskett, Thames & Hudson: 1980

Antique Radios by David and Betty Johnson, Wallace Homestead: 1983

Encyclopedia of Collectibles, Time Life Books Inc.: 1980

A Flick of the Switch by Morgan E. McMahon, Vintage Radio: 1975

The Radio Collectors Directory by Robert Grinder and George H. Fathauer, Ironwood Press: 1986

General Plastics by Raymond Cherry, McKnight & McKnight: 1941

The Story of Plastic Molding, Chicago Molded Products Corp.: 1940

Plastics Catalog, Plastic Catalog Corp.: 1943

The Encyclopedia of Antique Radio by J.W.F. Puett, Puett Electronics: 1979 and 1980

Photo Facts, Howard Sams & Co.: 1946-51

ACKNOWLEDGMENTS:

For their various courtesies and generous cooperation, thanks are due to:

Bob Breed
Richard Compton
Doug Heimstead
Bevis Hillier
Mark Honea
Morgan McMahon
Michael McCormick
Oscar Melton
Richard Nitz

Robert Patterson
Larry Pippick
Ed and Irene Ripley
Arnold Schwartzman
Edward Shelton
Jerry Simpson
Kay Tornborg
Baron Wolman
Amy Yutani

PERMISSIONS:

Emerson "Patriot" and "Raymond Loewy" advertisements: courtesy Emerson Radio Corp.

Hopalong Cassidy Instruction Leaflet: by kind permission of Arvin Industries Inc.

Coca-Cola advertisement: courtesy of the Archives. The Coca-Cola Company.

Belmont Radio Schematic used by the courtesy of the publisher, Howard W. Sams & Co.

'Raised On Radio' logo: courtesy Herbie Herbert Management Inc.

Tube box motifs: courtesy Joe Knight Collection.

Radio ephemera: courtesy Charles Bradley Collection.

The Daily News, October 31, 1938 courtesy The Daily News.

CROSSWORD SOLUTION

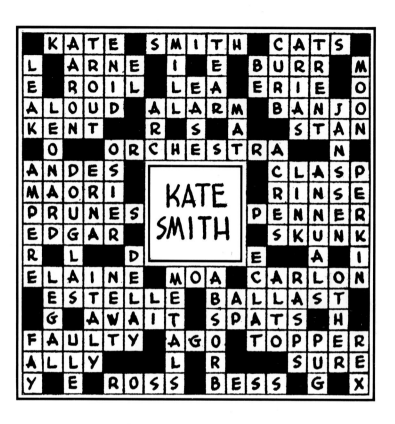